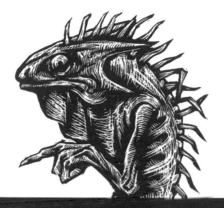

A PRE-COLUMBIAN BESTIARY

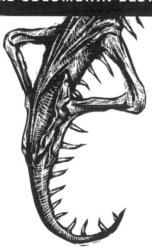

ILAN STAVANS

Etchings by Eko

The Pennsylvania
State University Press
University Park,
Pennsylvania

A PRE-COLUMBIAN

BESTIARY

**FANTASTIC CREATURES
OF INDIGENOUS
LATIN AMERICA**

For my "twin sister,"
Josefina López Caballero,
aka Vicky.

Library of Congress Cataloging-in-
Publication Data

Names: Stavans, Ilan, author. | Eko, 1958–
 illustrator.
Title: A pre-Columbian bestiary : fantastic
 creatures of indigenous Latin America /
 Ilan Stavans ; etchings by Eko.
Description: University Park, Pennsylvania :
 The Pennsylvania State University Press,
 [2020] | Includes bibliographical refer-
 ences and index.
Summary: "Explores forty-six religious, myth-
 ical, and imaginary creatures that are
 integral to the aboriginal worldview of
 Aymara, Aztecs, Incas, Maya, Nahua,
 Tabascos, and other cultures of Latin
 America"—Provided by publisher.
Identifiers: LCCN 2020013918 | ISBN
 9780271087870 (cloth)
Subjects: LCSH: Animals, Mythical—Latin
 America. | Indian mythology—Latin
 America.

Classification: LCC GR825.S83 2020 | DDC
 398/.469098—dc23
LC record available at https://lccn.loc.gov
 /2020013918

Published by The Pennsylvania
State University Press,
University Park, PA 16802–1003

The Pennsylvania State University Press is
a member of the Association of University
Presses.

It is the policy of The Pennsylvania State
University Press to use acid-free paper.
Publications on uncoated stock satisfy
the minimum requirements of Ameri-
can National Standard for Information
Sciences—Permanence of Paper for Printed
Library Material, ANSI Z39.48–1992.

Tell all the truth but tell it slant.

—EMILY DICKINSON

Contents

Preface

A few years ago, during a shamanic ceremony in Colombia, I ingested ayahuasca, made of *Banisteriopsis caapi*, a South American liana employed for hallucinogenic purposes. Ayahuasca is a "plant teacher." It pushes the mind into unforeseen realms. No wonder indigenous tribes in the Amazon make it an essential companion for religious quests.

Using words to describe what I went through defeats the experience. I wrestled with this challenge in the book *The Oven* (2018), which also became a one-man theater show staged across the United States. The extraordinary out-of-body education I had left a deep mark on me. I felt unconfined, physically as well as spiritually. At one point, I miraculously underwent a mutation that turned me into a jaguar roaming for prey in a vast landscape.

Once I got home, I immediately reread the *Popol Vuh* (1554–58), the sacred origin book of the Maya. I became fascinated by the multiple adventures of Hunahpu and Ixb'alanke, twins who at one point traverse the underworld, known as Xibalba—a habitat as intricate as Dante's hell—where they face, among dozens of other creatures, camazotz, bat monsters. In the narrative, these creatures have the terrifying strength of the Cyclops in Homer's *The Odyssey*.

I soon realized that in the shamanic ceremony I had also visualized myself into an assortment of other creatures, a few of them impossible to describe: part human, part-deity, with a few recognizable features but many more I had never encountered before. I delved into pre-Columbian sources—encyclopedias, testimonies of the Spanish conquest, historical chronicles of life in colonial times under European rule—in search of them. What I found astonished

me: the sources I looked at were themselves rather inconsistent and described these beasts in fanciful fashion.

It took me time to understand: this ethereal quality is precisely what makes these creatures distinct. I felt the inescapable urge to retell *Popol Vuh* for a contemporary readership; I also got the inspiration that led me to compile this anthology of pre-Hispanic imaginary beings, quoting from both real and fabricated sources. In the land of Magical Realism, what better way to pay tribute to these creatures than to celebrate their insubstantial status? (Julio Cortázar, in *La vuelta al día en ochenta mundos* [*Around the Day in Eighty Worlds*, 1967], writes: "I have always known that the big surprises await us where we have learned to be surprised by nothing, that is, where we are not shocked by ruptures in the order.") After all, I grew up in Mexico; I know how elusive the line between fact and fiction is. Latin America is where what is known and what is hoped for intermingle.

Needless to say, fantastic animals have always been present companions in human civilization. The Bible is full of them, not only unicorns and cockatrices (in the King James Version, 1611), angels and cherubim, but also Behemoth and Leviathan, aside, obviously, from the Almighty, an omniscient being with anthropomorphic qualities whose only limitation appears to be— surprisingly—not to have been able to clone itself.

The Greeks had sirens, centaurs, satyrs, chimeras, basilisks, phoenixes, Pegasus, Medusa, Cerberus, and other entities. The Middle Ages were a fertile era for the creation of these creatures too: golems, dragons, and griffins, among others, would all be considered cryptids today.

Modernity added its own contributions, such as Mary Shelley's *Frankenstein* (1823), Count Dracula, and the massive black earthworm known as Mihocão. The production of fantastic creatures has only intensified over the last century, especially in the English-speaking world, with J. R. R. Tolkien's *The Hobbit* (1937),

C. S. Lewis's The Chronicles of Narnia (1950–56), and, more recently, J. K. Rowling's Harry Potter saga (1997–2007).

Of course, what is fantastic to one culture is mundane to another. I ask myself, What did the indigenous people of Hispaniola, the first Caribbean island on which Columbus set foot, think of the Italian explorer and his companions? They probably believed the visitors were either demons or gods. As the Talmud (Tractate *Berakhot*) argues, we don't see the world as it is; instead, we see it as we are.

The Americas have long been a popular location to find monstrosities. Scientists like Charles Darwin and Alexander von Humboldt and writers like Andre Breton, D. H. Lawrence, Allen Ginsberg all presented these continents as puzzling, deceptive places. This isn't surprising; even today, the so-called New World remains a testing ground in which Europe envisions all sorts of enigmatic occurrences.

Jorge Luis Borges, along with Margarita Guerrero, edited the anthology *Manual de zoología fantástica* (Manual of fantastic zoology, 1957), expanded in 1967 and again in 1969 under a different title: *El libro de los seres imaginarios* (*The Book of Imaginary Beings*). It includes creatures like the pygmies mentioned by Aristotle and Pliny; the chimera, a three-headed beast with the head of a goat sprouting from its back, a lion's head at its front, and a snake's head on its tail; and Emanuel Swedenborg's angels, "the perfect souls of the blessed and wise, living in a Heaven of ideal things."

Perhaps most vividly, in Gabriel García Márquez's *Cien años de soledad* (*One Hundred Years of Solitude*, 1967), a series of bizarre creatures visit the town of Macondo, including the gypsy Melquíades, who dies dozens of times yet is always youthful, and the naïve and angelic Remedios la Bella, whose out-of-this-world beauty ultimately makes her fly into the sky—neither of which is portrayed as monstrous.

In truth, my interest in pre-Columbian creatures dates back further than my ayahuasca experience, to the late twentieth century,

when I first read Moacyr Scliar's *O carnaval dos animais* (*The Carnival of the Animals*, 1968), which is full of the most whimsical American fauna. In my personal library, I have an array of volumes that attempt to portray them, a few of them lavishly illustrated. I have acquired *artesanías* that are the equivalent of action figures. I have talked, sometimes at length, about this obsession of mine with scholars and writers like César Aira, Frederick Luis Aldama, Diana de Armas Wilson, José Donoso, Ariel Dorfman, Carlos Fuentes, Moshe Idel, José Emilio Pacheco, Ricardo Piglia, Miguel León-Portilla, Moacyr Scliar, Earl Shorris, Doris Sommer, and Juan Villoro.

The current selection of forty-six beings emphasizes gods and beasts from the Aymara, Aztecs, Inca, Maya, Nahua, and Tabascos. It is limited to American creatures, both existent and invented, from texts dating back to the sixteenth century, although some came to be—and were certainly recorded in historical documents—after the Conquest and during the colonial period that stretched until 1810. Regardless of their textual traces, these beings are grounded in oral tradition, recorded in the works of Fray Bernardino de Sahagún, Diego Durán, and other missionaries and later expanded upon by mythmakers such as Niño Benítez, Carlos Castaneda, Óscar Agustín Alejandro Schulz Solari (aka Xul Solar), and Guillermo del Toro. I'm deliberately loose with my primary source quotations and references, to the point of irreverence, distortion, and outright invention.

In my childhood and in travels during my adult years, I have personally seen a handful of these creatures with my own eyes. During a night of conversation, I described them in detail to the legendary Mexican artist Eko. His superb depictions are approximations based on indigenous codices.

Each entry begins with the creature's name, a guide to its pronunciation, and the culture from which it comes. The "Further Readings" section at the end of this book invites the reader to peruse authentic and fictional sources.

In spelling names, I have chosen to approximate, though not always endorse, the rules established by Bolivia's Instituto Iberoamericano de Lenguas Indígenas, Guatemala's Academia de las Lenguas Mayas de Guatemala, Mexico's Instituto Nacional de Lenguas Indígenas, and Peru's Academia Mayor de la Lengua Quechua.

My wholehearted gratitude to Patrick Alexander for his long-standing support, and to Alex Vose and Alex Ramos for their superb editorial work—three nonimaginary *Alex*es in a volume where coincidences reign.

—ILAN STAVANS

A PRE-COLUMBIAN BESTIARY

Acuecuéyotl

(*ah-kueh-ᴋᴜᴇʜ-yoh-tl*, Nahua)

The literal meaning of Acuecuéyotl is "wave of water" or "skirt of water." The name refers to the sister to Tláloc, the god of celestial water. She also goes by the name of Chalchiuhtlicue.

She is similar to a nymph, and like the siren of Greek mythology, she lures sailors with her singing voice and enchanting music. Acuecuéyotl is a wraithlike being who wears large round earrings, a pearl necklace, and a modest golden crown. Her beauty is delicate. Her physical appearance changes depending on the hour of the day. In lieu of hair, she has a sprawling maguey that leaks a seductive liquid.

Water for the Nahuatl was considered the earth's nectar. Acuecuéyotl is said to reign harmoniously over rivers, lagoons, and the endless oceans. All those navigating on water were said to pay tribute to her. She is supported in her endeavor to fertilize the soil by the tlaloque, water creatures that, according to Ángel María Garibay's *Teogonía e historia de los mexicanos: Tres opúsculos del siglo XVI* (Theogony and history of the Mexican people: Three small works of the sixteenth century, 1985), are tasked with accumulating water in immense containers. The thunder that people hear in the middle of a rainstorm is the sound the tlaloque make as they smash the containers with enormous sticks, allowing the water to spill without aim.

Dominican friar Raúl Diego Santánder, in his book *Libro de estrellas* (*Book of Stars*, 1573–75), describes Acuecuéyotl as "a lover in a state of ecstasy." He adds, "To be overwhelmed by it is to understand life's true meaning."

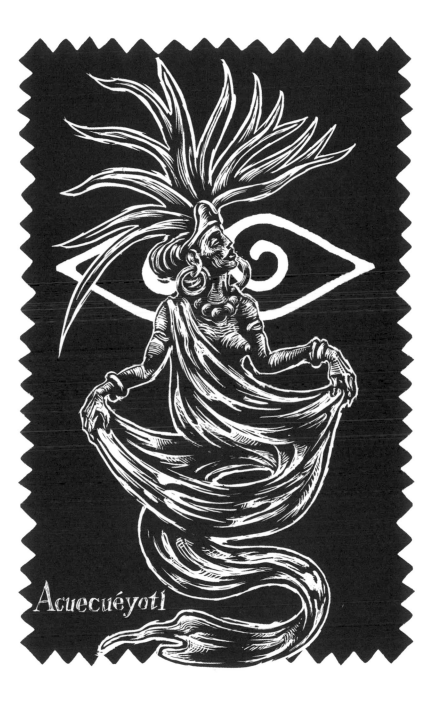

Acuecuéyotl

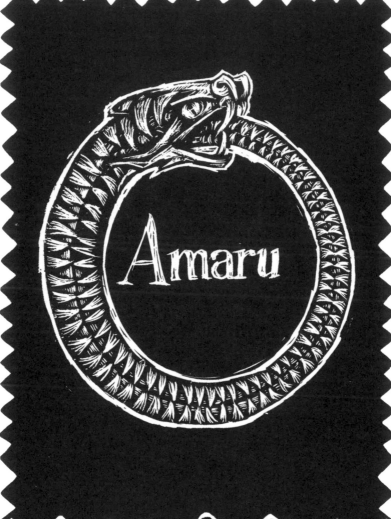

Amaru

(*a-MAH-roo*, Inca)

The Inca people admire the Amaru. It is one of three sacred animals. The other two are the Kuntur and the Uturunku. The Amaru is a potent snake. The architecture of the citadel called Sacsayhuaman, in the northern outskirts of Cusco, is made to mimic its shape. That shape is considered a divine triumph in construction. (Elias Canetti, author of *Masse und Macht* [*Crowds and Power*, 1960], was an admirer of mimicry; he believed writing, teaching, parenting, loving, believing in the divine, and even quoting the Bible all depend on mimicry. Julio Cortázar, in *Bestiario* [*Bestiary*, 1951], was equally mordant in his appreciation of imitation. "In quoting others," he stated, "we cite ourselves.")

The Amaru is astonishingly flexible, allowing it to roam unimpeded. Its skin changes with the colors of the environment, allowing it to camouflage itself as a means of protection. More significantly, it has the quality of being able to devour itself in full, appearing and disappearing at will. It might reshape itself into a cougar, which the Inca call a puma.

Its sacred versatility makes it "utterly untamable," argues "El Inca" Garcilaso in his *Comentarios reales de los incas* (*Royal Commentaries of the Inca*, 1609): "With artifice the Inca domesticated and united a large variety of nations diverse and opposing in idolatry and customs, finding and subduing them to their empire, and they made them unite and be friendly with one another through their language. They also subdued the animal kingdom, but never the Amaru, which was forever beyond their capacity."

Azcatl

(ATZ-*kah-tl*, Nahua)

The Azcatl is an enormous ant, the size of three jaguars. Its body consists of a series of never-ending curves, which have the capacity to hypnotize its pray. According to the ancient Nahuatl legend, the original Azcatl was created in order to defend Aztlán, the "place of the herons." It is the location—a kind of Xanadu, somewhere in today's Utah or Nevada—from where the original Mexicans walked south in search of a place to settle. Their elders described their destination as a series of lakes with a rock emerging in the middle. A cactus would grow from the rock. On top of the cactus, an eagle would be devouring a serpent. Throughout their journey, the Azcatl protected the Mexicans by confounding their enemies through hypnosis.

In some graphic depictions, the Azcatl looks like a spider (Arachnida), with an internal respiratory surface in the form of tracheae, lateral and median eyes (ocelli), and sensory hairs that provide them with a sense of touch. In his diaries, Franz Kafka considered various words to describe the shape of Gregor Samsa, protagonist of the novella *Die Verwandlung* (*The Metamorphosis*, 1915), opting in the end for *Ungeziefer*, a term from Middle High German meaning "unclean animal not suitable for sacrifice." In English, *Ungeziefer* has been translated as cockroach, beetle, and other insects. In passing, Kafka, who suffered from dream-like, hypnagogic hallucinations during a sleep-deprived state leading to the writing of the novella, mentions looking at a pictorial dictionary of Nahuatl creatures and pondering the Azcatl as an option. "Too seductive!" he states (entry of March 16, 1913).

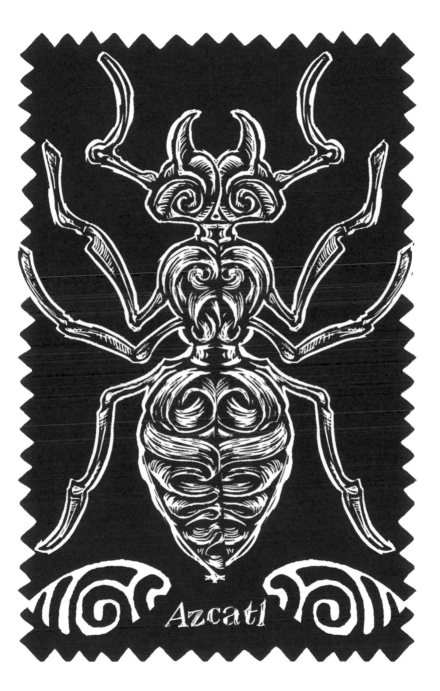

Azcatl

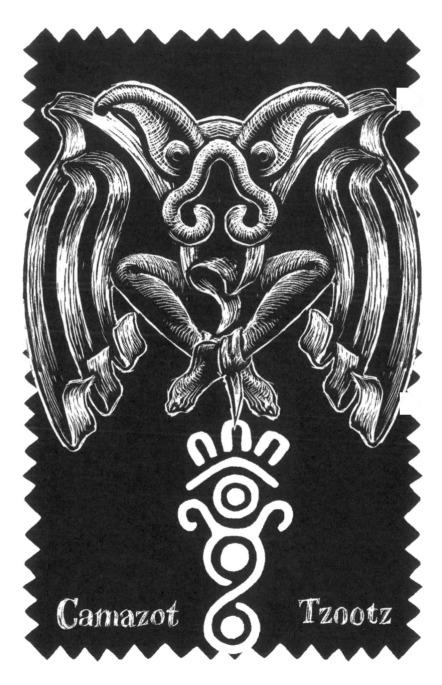

Camazot Tzootz

Camazot Tzootz

(*ka-ma-zoth tzootz*, Aztec and Maya)

Alternative spellings: Kamalotz and Cama-Zotz Sotz. Sotz are bats and Camazot Tzoots is a bat goddess. The literal meaning of her name in K'iche is "death bat."

She is enormously flexible, growing or shrinking as necessary. Her aerodynamic wings are serpentine, twisting and turning in threatening fashion as she navigates the skies. She visits men who are disloyal, are unreliable, or have been dishonored in war. Her nose is a large hole around which a serpent-like edge simulates nostrils. Although she has human legs, knees, and feet, she seldom uses them. When overwhelming a victim, Camazot Tzoots emits a loud lethal sound. She drinks fresh blood. Yet she is gentle in her execution, avoiding as much as possible any suffering.

Camazot Tzootz makes an appearance in the ancient Maya book *Popol Vuh*, preserved through oral tradition until 1550, when the K'iche people made an effort to transcribe it. As they travel through Xibalba, the underworld, the twin protagonists Hunahpu and Ixb'alanke face the camazotz, bat-like monsters over whom Camazot Tzootz reigns. At one point, they spend a night in the House of Bats. When a desperate Hunahpu sticks his head out to find out if the sun has risen, the camazotz decapitate him. They take his head to the deities for their next game. They hang up the head as a ball.

According to Javier López Mezquites's *Luna sobre Mesoamérica* (Moon over Mesoamerica, 1929), in the oral version of *Popol Vuh* Camazot Tzootz asked for Hunahpu's blood. Her request was denied after Ixb'alanke fought her.

Chaac

(*TCHA-ak*, Maya)

Also spelled Chac and Chaahk. This is another deity of water, the equivalent among the Maya of the Nahua goddess Acuecuéyotl. Chaac uses an ax to strike the clouds with enormous power, thus bringing down a rainstorm. With a long, hanging nose shaped like a curly hose and a toothless mouth from which hangs a twirling thread, she is depicted as part bird and part serpent.

Chac Xib Chaac was the king of the city of Chichen Itza, in the Yucatán Peninsula. When I last visited, Vaier Librado Martínez, a guide, told me that Chac Xib Chaac was created after the goddess Chaac copulated with humans. The king was capable of swimming an infinite number of kilometers without ever feeling exhaustion. Fish, sharks, manta rays, octopuses, and other sea creatures accompanied him dutifully. He could breathe underwater. His mother, Chaac, was always at his side.

However, she wished she could have been human, "envying the capacity people have of living on land, walking on two feet, using their hands to eat and move objects, and 'breathing unimpededly with harmony'" (Diego de Landa, *Relación de las cosas de Yucatán* [*History of the Things of Yucatán*, 1566]).

According to José Donoso's *El obsceno pájaro de la noche* (*The Obscene Bird of Night*, 1970), the Chaac might be related to the Chilean invunche, a malformed human creature whose head is twisted backward. It also has warped limbs and misshapen nose, mouth, ears, and—in some cases—fingers on one or both hands. With a leg attached to its neck, the invunche walks either on one foot or on three feet. Like the golem imagined by Gustav Meyrink in *Der Golem* (*The Golem*, 1914) and by Gershom Scholem in his book *Major Trends in Jewish Mysticism* (1941), the invunche can't talk; it communicates only through guttural, undecipherable sounds.

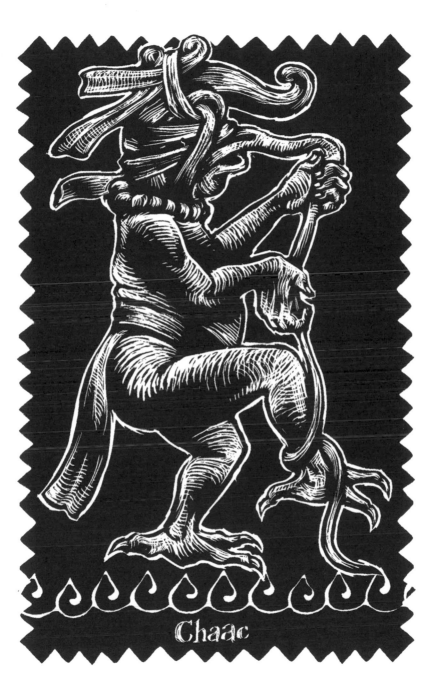

Chaac

Chachalaca

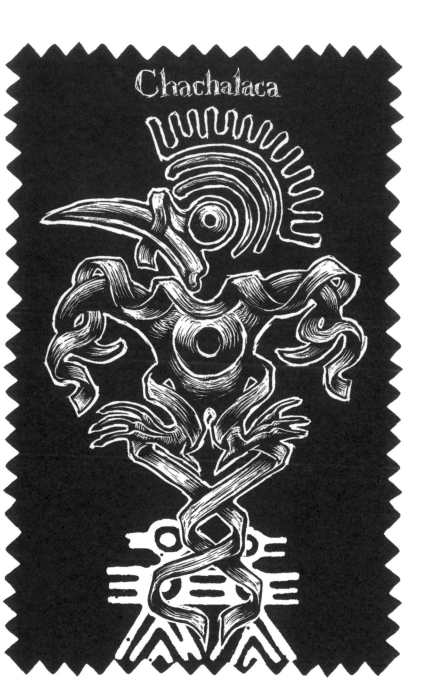

Chachalaca

(*tchah-tchah-LAH-kah*, Nahua)

The word means "tattler, gossiper." The chachalaca is a bird of the family Cracidae (which also include guans and curassows) first identified in 1815 by the French scientist Constantine Samuel Refinesque. There are several varieties. In Trinidad and Tobago, there are two types: the Trinidad piping guan and the rufous-vented chachalaca. In Colombia, there is the variety identified by the scientific name of *Ortalis columbiana*. Elsewhere, there is the West Mexican chachalaca, *Ortalis poliocephala*; the white-bellied chachalaca, *Ortalis leucogastra*; the gray-headed chachalaca, *Ortalis cinereiceps*; and the plain chachalaca, *Ortalis vetula*. The one connected with the Nahua, *Ortalis canicollis*, has a long feathered tail and a sharp beak. It showcases a range of colors, including yellows, browns, oranges, and sometimes greens. Only rare specimens are known to sing.

The chachalaca I saw in 2014 in Cholula, in the western section of the Mexican state of Puebla, lived in a monumental tiger's claw tree (*Erythrina variegata*). The local population believed it was sacred because of its music. It was known to sing at regular hours in multiple languages at once: Spanish, Nahuatl, K'iche, Hebrew, and Sanskrit.

Chapulín

(*tchah-poo-LEEN*, Nahua)

The word comes from the Nahuatl *chapolin* or *chapolimeh*. The chapulín is a grasshopper, which is the most ancient living group of chewing herbivorous insects. Biologists date the chapulín to the Triassic period, approximately 250 million years ago.

They are brown and have antennae and wings. Known for their happy spirit and their small size, they are ubiquitous in Mesoamerica from early May to late August.

The Nahua consider the chapulín a messenger of the world beyond. When a person eats it, its power to speak with the dead is passed on to the eater. In Oaxaca, toasted chapulines are served with fried eggs. There are also tacos de chapulines. Likewise, chapulines are served as a snack with lime juice, garlic, and salt.

Fray Luis de Buenaventura was an aficionado of the sounds of the chapulín, which he believed to be one of the most remarkable creatures on earth, known for its inexhaustible patience. He thought it wise for humans to imitate that composure. In *Historia parcial de la Nueva España* (*Partial History of New Spain*, Florentine Codex, 1551–63), Buenaventura states that "what is carved should be original, and have life, for whatever may be the subject which is to be made, the form of it should resemble the original and the life of the original. . . . Take great care to perceive what the animal you wish to imitate is like, and how its character and appearance can best be shown."

The chapulín became a colorful superhero, El Chapulín Colorado, in the popular TV show *El chavo del ocho* (The boy from number eight, 1973–79), created by Roberto Gómez Bolaños. My father was part of the cast.

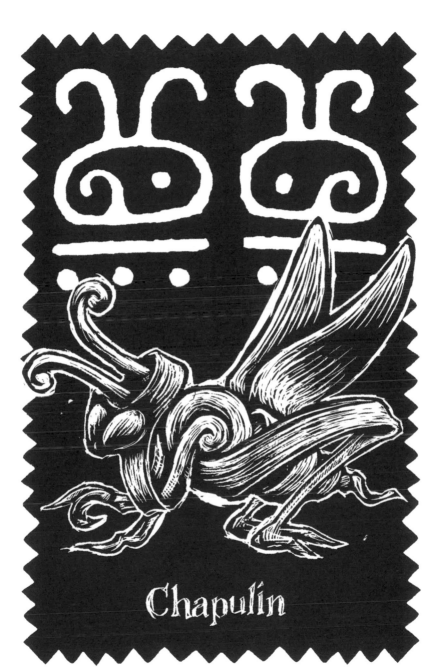

Chapulín

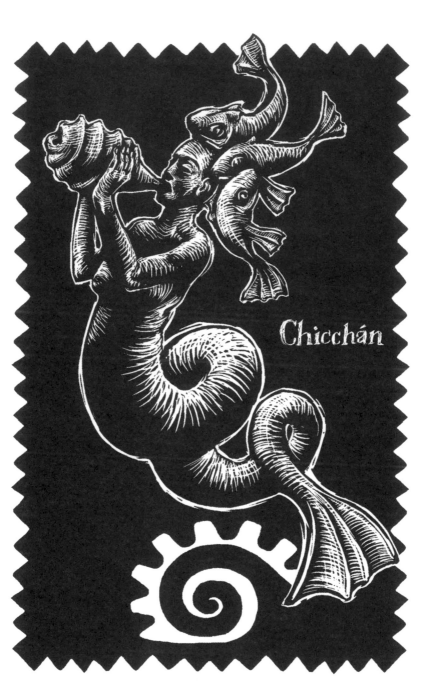

Chicchán

Chicchán
(*tcheek-TCHAN*, Maya)

According to the Maya, the world is sustained by four mythical serpents, which create an enormous circle around the earth and serve as its protectors. Serpents bring about rain and make the soil fertile. The Chicchán is one of those serpents.

The Chicchán has a woman's face, a fish tail that makes her resemble a mermaid, and hair made of trout. She blows a conch shell to announce approaching dangers. Her demeanor is sleazy. She is known to seduce generals and is able to instantaneously heal their wounds.

César Aira, author of *Un episodio en la vida del pintor viajero* (*An Episode in the Life of a Landscape Painter*, 2000), wondered if Alexander von Humboldt, in *Reise in die Äquinoktial-Gegenden des neuen Kontinents* (*Personal Narrative of Travels to the Equinoctial Regions of the New Continent*, 1818), confused the Chicchán with the remora (Latin for "delay"), a fish—sometimes called a suckerfish—popularly believed to have the capacity to stop ships on their journeys across the ocean.

The Chicchán doesn't stop ships, but it, along with the other three mythical serpents, is known to move mountains and rivers.

Chuen

(*TCHOOen*, Maya)

The Chuen is a symbol of irritation as well as harmony, opposites that attract each other. This creature is a monkey wearing a crown made of plantain leaves. In the front, the crown has an eye made of emerald, jade, and amethyst. The Chuen has human teeth and four human arms (two instead of legs), and it always wears onyx rings. It is accompanied by a skull, which the Chuen uses as a bongo to instigate anger. The monkey is rapidly annoyed by acts of human futility.

The Chuen is also a symbol of harmony. It knows the past, present, and future and is able to travel freely between them. Munro Edmonson's *Heaven Born Merida and Its Destiny: The Book of Chilam Balam of Chumayel* (1986) described it as having been created with the vanished city of K'aak Chi (Mouth of Fire) in the Yucatán, in the crown's eye, making it the city's indispensable companion. (K'aak Chi was discovered by fifteen-year-old William Gadoury, from Quebec, Canada, through Google Earth images.) In the section called "The Birth of Uinal," Edmonson describes the Chuen as prophetically counting steps back and forth in order to measure the landscape on which "a future city will be built one day."

Occasionally, the Chuen has been confused with the carbuncle, a small creature spotted by Spanish conquistadores that, according to *El libro de los seres imaginarios* (*The Book of Imaginary Beings*, 1967), edited by Jorge Luis Borges and Margarita Guerrero, supposedly "has some sort of shining mirror or jewel on its forehead, reminiscent of the gemstone by that name. Many explorers supposedly searched for it, hoping to secure a precious stone—but without success."

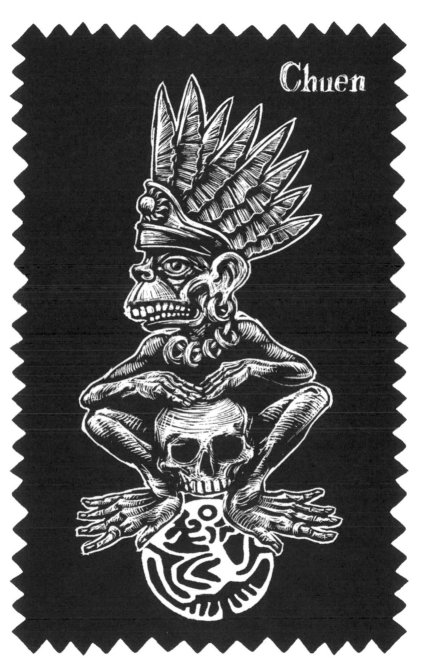

Chuen

Colotl

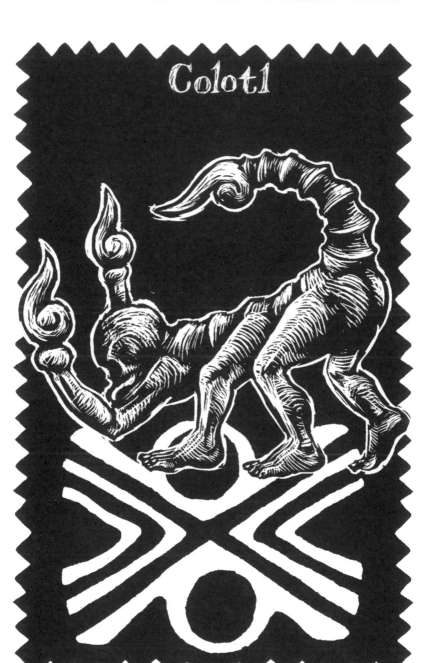

Colotl

(*koh-LOH-tl*, Nahua)

According to Frances Karttunen in *An Analytical Dictionary of Nahuatl* (1983), the word Colotl comes from Nahuatl *koolootl*. It refers to a scorpion with the head of a primate, human feet, and a dangling tail that ends like a flame. Its forelimbs also have the same flame shape.

Ethereal, though never sinister, the Colotl is believed to live exclusively in people's dreams, traveling effortlessly from one person's dream to another's. According to Sigmund Freud, it is particularly prone to inhabit the dreams of individuals suffering from hysteria. In his *Studien über Hysterie* (*Studies on Hysteria*, 1895), coauthored with Josef Brauer, he described the Colotl as "a form of strangulated affect."

In *Cantares mexicanos*, fol. 13v (1984, included in Miguel León-Portilla's *The Aztec Image of Self and Society*, 1992), there is an apropos poem about the Colotl called "We Come Only to Dream":

> Thus spoke Tochihuitzin,
> thus spoke Coyolchiuhqui:
>
> We only rise from sleep,
> we come only to dream,
> it is not true, it is not true,
> that we come on earth to live.
> As an herb in springtime,
> so is our nature.
> Our hearts give birth, make sprout,
> the flowers of our flesh.
> Some open their corollas,
> then they become dry.
>
> Thus spoke Tochihuitzin,
> Thus spoke Coyolchiuhqui.

Coyametl

(*co-ya-MEH-tl*, Aztec)

A mix between wood-pig and boar, this gregarious beast is capable of jumping over large barriers. In mestizo culture, it is known as a Quapisoti or Jabalí.

Yólotl González Torres, in *Diccionario de mitología y religión de Mesoamérica* (Dictionary of Mesoamerican mythology and religion, 1995), claims its principal source of nutrients is knives. The Aztecs also believed it could make corn grow at twice its regular speed.

In the "Legend of Coyametl and the Rooster," structured as a traditional folktale, the Coyametl befriends a seven-year-old boy. After a while, the Coyametl tells the boy he will be granted three wishes. The boy first asks for corn to grow in less than a day. The Coyametl makes the first wish come true. The second wish is that a princess should be sacrificed in the pyramid of Teotihuacán that same night. Again, the Coyametl grants him the wish. Then the boy, not knowing what to ask for, loses track of how many wishes he has already made. He casually says, "I wish I hadn't wasted the first two wishes. I could have asked to become a rooster." And so the boy ends up as a rooster.

Juan Rulfo, author of *El llano en llamas* (*The Plain in Flames*, 1953), talked about the Coyametl to Gabriel García Márquez and Carlos Fuentes when they were adapting his story "El Gallo de Oro" ("The Golden Rooster") for the screen in Mexico in 1964. "It is the opposite of a rooster," Rulfo said.

Hans Gadow, in his *Through Southern Mexico: Being an Account of the Travels of a Naturalist* (1908), writes, "This gregarious beast is easily recognizable by its generally dark reddish-brown colour, whilst the belly, chest, throat, cheeks, and a narrow ring across the snout are white. The usual name of all these creatures is the Spanish-Arabic Jabalí" (73).

Coyametl

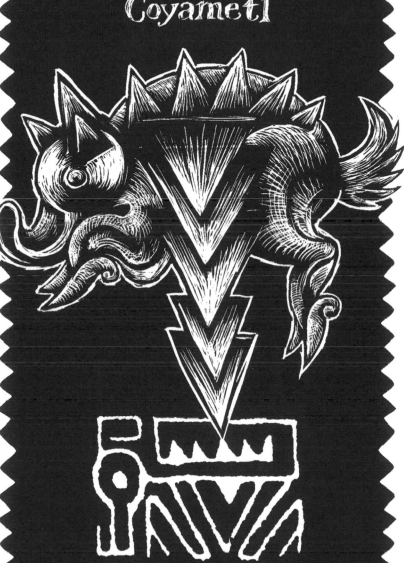

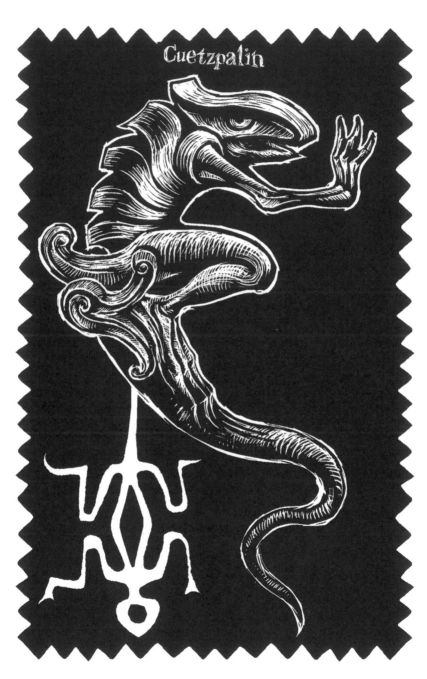

Cuetzpalin

(*coo-etz-pa-leen*, Nahua)

This long-tailed lizard is usually found in a vertical position. Behind the hips, this reptile has a seductive joint, known to hypnotize those who look at it closely. In *El pensamiento náhuatl cifrado por los calendarios* (Nahuatl thought as found in calendars, 1981), Laurette Séjourné described the cuetzpalin as "a guacamole beast" that "run[s] with a strong side-to-side motion," as other quadrupeds do, except this one "feeds on avocado and calves, lambs, roosters, bulls, turkey, and even human testicles."

The cuetzpalin is known for its poisonous bite. It secretes a venom that prohibits molecules of the neurotransmitter acetylcholine from interacting. The victim stops breathing within thirty minutes.

In a voyage to Toluca, I was once taken to a home with a large collection of cuetzpalins. They were kept in fish bowls. The owner, Santiago Berbané Domínguez, on staff at a Toluca morgue, was known to cut the testicles from human cadavers, boiling them in water, smooshing them, and mixing the paste with avocado to make their food.

According to Silke Friedrich-Sander's *Johann Moritz Rugendas: Reisebilder zwischen Empirie und Empfindung* (Johann Moritz Rugendas: Travel pictures between empiricism and sensation, 2017), in a 1931 trip to Mexico, German painter Johann Moritz Rigendas, famous for his depictions of ethnographic subjects in the Americas, painted "a real cuetzpalin I found in the terrace of a hotel," using the method of the *camera obscura*. He told Mexico's president, Anastasio Bustamante, "It bit me through a mirror."

Dzaby

(*DJA-bee*, Maya)

Known in English as a dragonfly, this insect belonging to the infraorder of Anisoptera is characterized by an elongated body, strong, transparent wings, and large, multifaceted eyes.

The dzaby is a uniquely logocentric insect. It feeds on a diet of letters. Different species prefer particular selections: in the Peruvian Altiplano, dzabys feed on *B*s, *H*s, *T*s, and *Z*s; in the Mexican state of Quintana Roo, they prefer to *N*s, *X*s, and *Y*s; and in Hidalgo, dzabys pullulate toward three vowels: *A*s, *E*s, and *O*s.

However, a Maya legend suggests that the first dzaby wasn't attracted to the alphabet. Instead, it thrived in labyrinths, building nests in various locations inside them, then training itself to recognize various routes in and out of the maze.

Enrique Jardiel Poncela, the twentieth-century Spanish romantic novelist and playwright, author of *Amor se escribe sin hache* (Love is spelled without *H*, 1928), imported a dzaby colony from Cozumel to Madrid. He wrote a famous essay, "Una letra protestada y dos letras a la vista" (One protested letter and two letters on sight, 1942), in which he shrewdly called dzabys "the only creatures in the animal kingdom whose life is alphabetized."

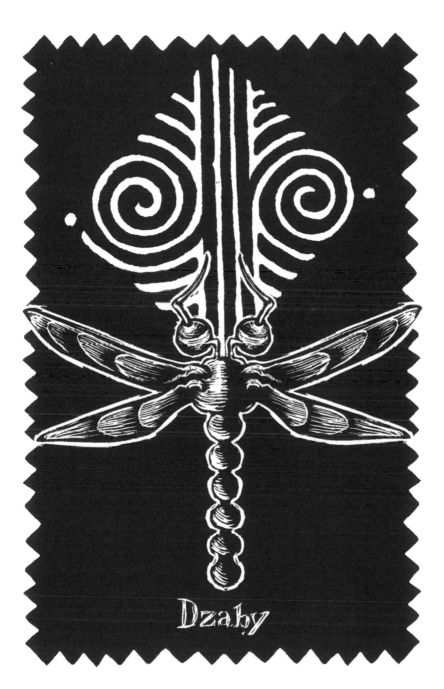

Dzaby

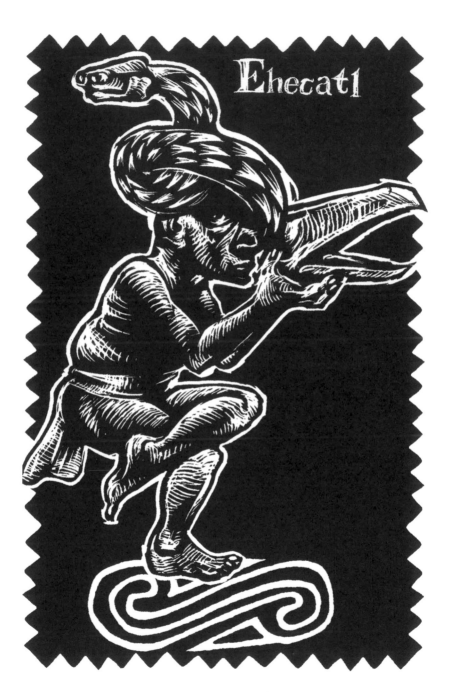

Ehecatl

Ehecatl

(*eh-heh-ᴋᴀᴛ-tl*, Nahua)

Associated with Quetzalcóatl, the fathered serpent god of the Aztecs, the Ehecatl has myriad shapes. It might take human form, or it might also appear as a peacock. It has a large beak and a serpent-like hat. There once was a stone statue of it in the Museo de Antropología in Mexico City. It was purportedly stolen by a staff member in 2007.

Ehecatl isn't quite Quetzalcóatl. Some scholars view it as a sibling, while others see it as an incarnation of Quetzalcóatl's spirit. The feathers Ehecatl wears are of a toucan.

After Ehecatl died, in the second sun cycle, various sages prophesized the return of the deity in the form of a tall bearded man in iron clothes. The arrival of Hernán Cortés was therefore confused with Ehecatl's reincarnation. This explains why the Aztec emperors didn't resist the Spanish conquistadores. Instead, they showered them with gifts.

Unfortunately, David Carrasco, in *Quetzalcoatl and the Irony of Empire: Myths and Prophecies in the Aztec Tradition* (1982), the most authoritative disquisition of the serpent god, makes insufficient reference to the Ehecatl.

Hixx

(*HEEKS*, Maya)

Also known as Estavchetl, this creature has the shape of a leopard mixed with a lizard. It comes alive with copal (incense) and pozole (hominy porridge). In the design of the Hixx's skin, a person might be able to learn of pasts that never materialized.

Alfred M. Torzer's *A Maya Grammar* (1921) includes an anonymous song about the Hixx:

> I am restoring it,
> my offering of copal [incense] to you,
> for you to restore me, Father,
> for you to raise it up to the Father.
>
> I will pay you,
> my offering of pozole,
> for your welfare.
>
> As long as you allow me a peak to the pasts I never lived,
> to my other selves,
> to the person I might have been,
> or was,
> or shall be in another world.
>
> May I not be affected by distress.
> Enter, walk, restore me,
> make me whole.
> See in me the possibilities of other lives.

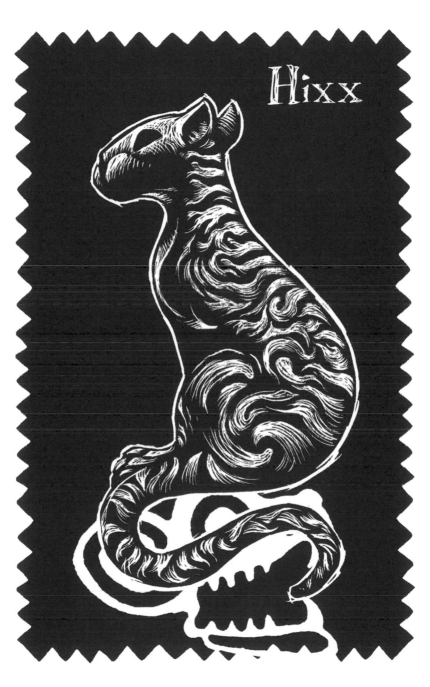

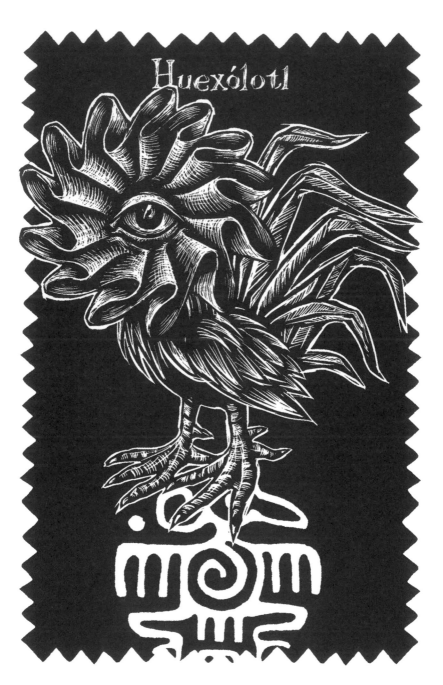

Huexólotl

(weh-ᴋsoʜ-loh-tl, Aztec)

Known for eating shadows, the Huexólotl (also spelled Huezólotl) is a rooster with an enormous head composed of a flower with an eye in the center. Guatemalan poet Humberto Ak'abal describes it thus in *In the Language of Kings: An Anthology of Mesoamerican Literature, Pre-Columbian to the Present,* edited by Miguel León-Portilla and Earl Shorris (2001):

> I walked all night
> in search of my shadow.
>
> Huezólotl,
> you eat darkness.
>
> Utiwwwwww . . .
> a coyote.
>
> Tu tu tukuuuuuurr . . .
> an owl.
>
> Sotz', sotz', sotz' . . .
> a bat chewing the ear
> of a little pig.
>
> Huezólotl, you took away my shadow.
> Who am I now?

Huitzin

(*WEET-tzeen*, Nahua)

The huitzin is a hummingbird (in Spanish, *colibrí*) that lives wherever cempasuchil flowers grow. A Maya legend tells of Xóchitl and Huitzilin, a young girl and delicate boy. Hiking was their favorite pastime. At the end of their treks, they would offer flowers to the sun god Tonatiuh, who thanked them for the present.

When war broke out, Huitzilin was sent to the battlefield, where he died. In desperation, Xóchitl went on a hike to the place where Tonatiuh was. The hummingbird followed her. She asked to be turned into a flower. Tonatiuh agreed to her request. He turned her into a campasuchil flower, but not before bringing back Huitzilin in the form of a hummingbird, which he named Huitzin. He promised her that the hummingbird would always be near the flower.

It is said that Huitzin metamorphosed into Huitzilopochtli, "Blue Sky," the left-handed colibrí. According to *Pre-Columbian Literatures of Mexico*, edited by Miguel León-Portilla (1969), the Florentine Codex says in book 3, chapter 1, says that when Huitzilopochtli was born, "he put on his gear, his shield of eagle feathers, his darts, his blue dart thrower, and his turquoise dart thrower. He painted his face with diagonal stripes, in the color called 'child's paint.' And he went out in search of Xóchitl" (206).

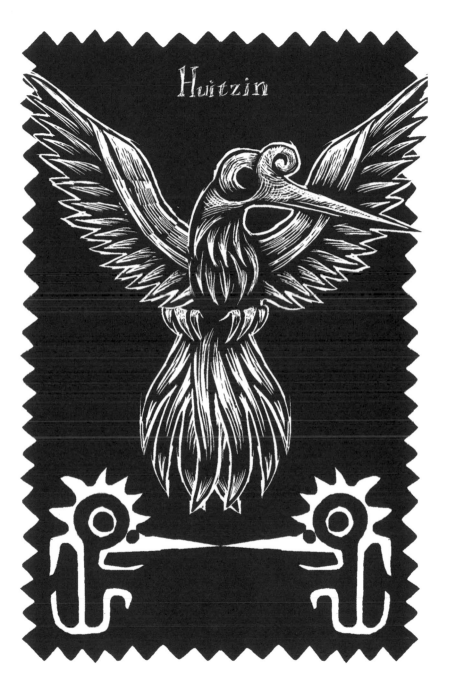

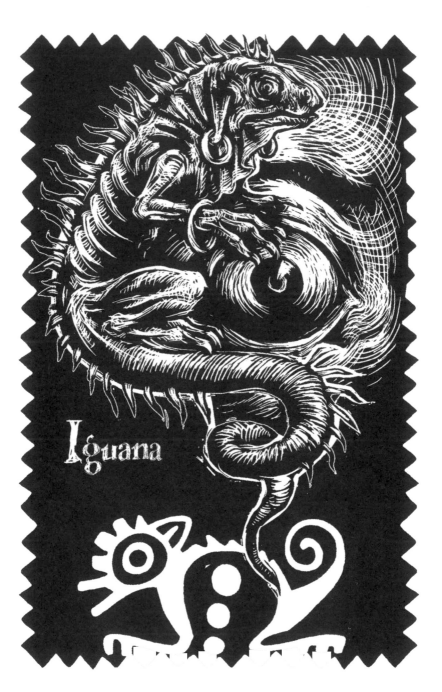

Iguana

Iguana

(ee-GUAH-nah, Aztec)

The iguana is a genus of herbivorous lizards ubiquitous in Meso-america. Yet the mythical *Iguana azteca*, as King Cuauthémoc is believed to have referred to this most unique species while Hernán Cortés and his army tortured him by burning the soles of his feet, is almost never seen. Its first scientific description is in Austrian naturalist Josephus Nicolaus Laurenti's *Specimen medicum, exhibens synopsin reptilium emendatam cum experimentis circa venena et antidota reptilium austriacorum* (*Medical Treatise, Exhibiting an Emended Synopsis of Reptiles, with Experiments Concerning Venoms and Antidotes for Austrian Reptiles*, 1768), in which he described it as "defined by opposites: big and small, fat and slim, beautiful and ugly, cantankerous yet amicable." Laurenti was particularly taken by the fact that this creature has two hemipenes and that during copulation one hemipene is inserted into the female's cloacal vent while the other lays flaccid.

Contrary to common sense, a history of common Aztec animals composed by Fray Gerardo Tobar Bensusén in 1534 argues that the most important nutrient for iguanas is mezcal. Juan Herrera Jaén, the Mexican author of *El libro criminal* (*The criminal book*, 2008), wrote a disquisition on why iguanas are "possessed by the flavor of Mexican penicillin." Herrera Jaén emphasizes the qualities of both iguanas and mezcal by quoting two popular sayings: "Iguanas, like mezcal, make you rethink the worm" (71) and "Be careful: one mezcal is just right, two is too many, and three is not enough since by then you've turned into an iguana" (139).

Imix Cipactli

(*EE-miks see-PAK-tlee*, Maya)

This is a crocodilian alligatorid belonging to the family Caimaninae. Commonly known as a caiman, it is found in marshes and swamps, keeping a nocturnal routine. With its scaly skin, the Imix Cipactli was only seen once, by German botanist and phytogeographer Andreas Franz Wilhelm Schimper. He described it as having "the shape of a staircase." Dutch artist Maurits Cornelius Escher is known to have been obsessed with it. It was a source of inspiration for his piece "Relativity" (1953).

Imix Cipactli

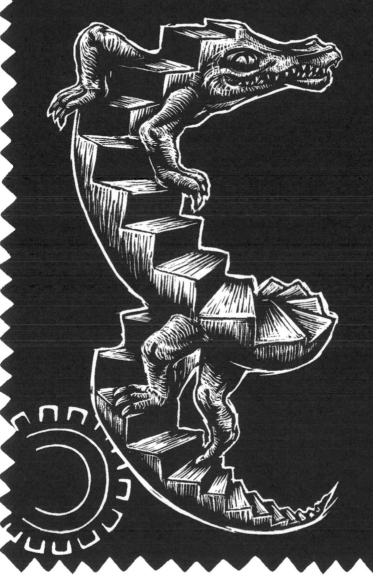

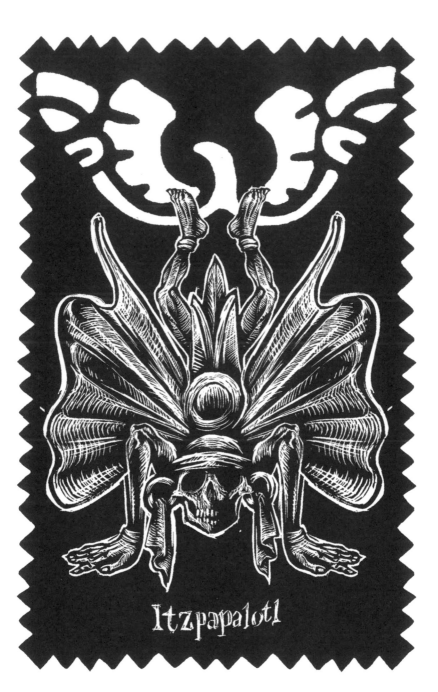

Itzpapalotl

Itzpapalotl

(*EETZ-pah-pah-LOH-tl*, Nahua)

In Aztec mythology, she is the goddess of Tamoanchan, the paradise inhabited by dead children. Taking the form of an obsidian butterfly, Tamoanchan is also where human beings originate. Itzapapalotl is close to birds and in touch with fire. Her face is that of a calavera. She might acquire the form of a deer and transform herself into a woman in order to seduce men.

It is said that every time a child flies a kite (in Nahuatl, *papalote*), Itzapapalotl imprints on its wings the route it will navigate.

Kay

(*KAI*, Maya)

Kay is an androgynous dancer with fish instead of hands. S/he also has several fish tied to his/her head. It is thought that Kay copulates with him/herself. With repeated oscillations, the dancer is known to become a pirinola, a spinning top.

Inexplicably, at various points Kay has been linked with Lewis Carroll's Jabberwocky in *Through the Looking Glass, and What Alice Found There* (1871). Sandra Raziel Palante, a Maya poet from Quintana Roo, constructs his volume *El jinete con juanete* (The horseman with bunion, 2019) around the killing of a beast called Kaybberwock. He uses as his urtext the Spanish version of Jabberwocky by Mirta Rosenberg and Daniel Samoilovich (*Diario de Poesía*, September 1997). To show the link, I quote the second and third stanzas—from Rigoberto Espaillat's *Jabberwocky in Latin America* (2002)—first in Carroll's original, then in Palante's tribute:

> "Beware the Jabberwock, my son!
> The jaws that bite, the claws that catch!
> Beware the Jubjub bird, and shun
> The frumious Bandersnatch!"
> He took his vorpal sword in hand;
> Long time the manxome foe he sought—
> So rested he by the Tumtum tree
> And stood awhile in thought.

> "¡Con el Kaybberwock, hijo mío, ten cuidado!
> ¡Sus sexos que destrozan, sus mañas que apresan!
> ¡Cuidado con el pez Jubjub, hazte a un lado
> si vienen las frumiantes Romburgezas!"

> Empuñó decidido su espada vergoral,
> buscó largo tiempo al monxio enemigo—
> Bajo el árbol Tamtam paró a descansar
> y allí permanecía pensativo.

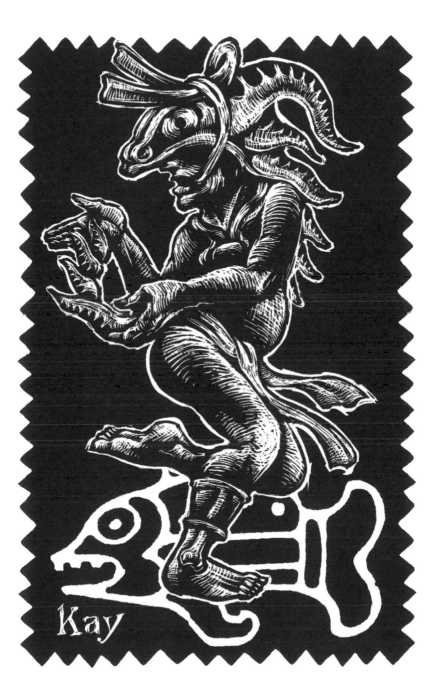

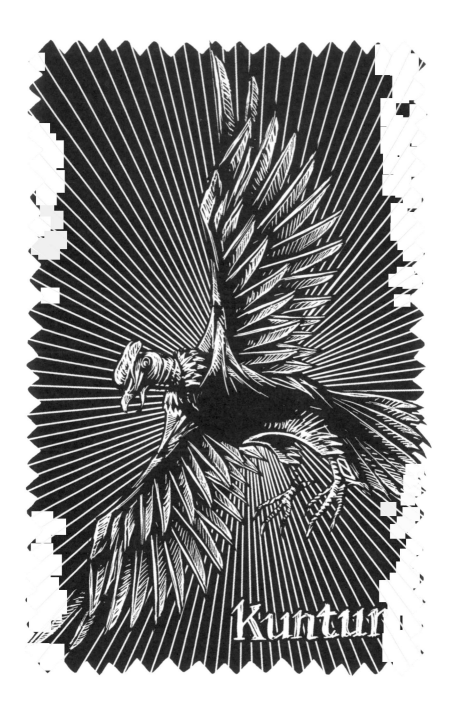

Kuntur

(*KOON-toor*, Inca)

The common word for kuntur in Bolivia is condor. One of the three sacred Inca animals, it is among the largest birds to fly.

The *Vultur gryphus* lives in the Andes. Its plumage is uniformly black, except for a ring of white feathers surrounding its neck. The head is flat; the feet are elongated. Kunturs live fifty years, sometimes more.

Occasionally, the kuntur has a pink head and blue beak. Together, they might look like human intestines.

In Machu Picchu, there is a temple devoted to Kuntur.

Lama Glama

(*LAH-ma GLA-mah*, Aymara)

The *Lama glama* is the most common type of llama, a domesticated camel. The Inca deity Urcuchillay was a multicolored llama. In Aymara civilization, the llama is an animal known for its empathy and warmth.

It is said that the llama was designed by the deities to help humans overcome their own limitations. In particular, the *Lama glama* appears in a story about sacrifice by chronicler Fernando de Zarzamora, *Vida y obra de la llama que llama* (Life and times of the calling llama, 1903). A magician was in search of a potion capable of healing the village of Temporyia from its sins. One day, the magician found a talking llama near a series of animal-shaped rocks. "You shall climb the highest mountain," the llama said. "At the top you'll find sunflower seeds. Plant them in your garden. They will grow fast. Turn them into food to feed the village." The magician did as he was told. After feeding the entire population, he noticed a smile in every face. "We are cured from evil," they told him. The magician looked for the llama to convey the news. But the llama had turned into a stone, just like other ones had done before.

Besides the parrot Polynesia, the pig Gub-Gub, the duck Dab-Dab, the monkey Chee-Chee, and the owl Too-Too, it is the central character in Hugh Lofting's series of books *The Story of Doctor Dolittle* (1920–33).

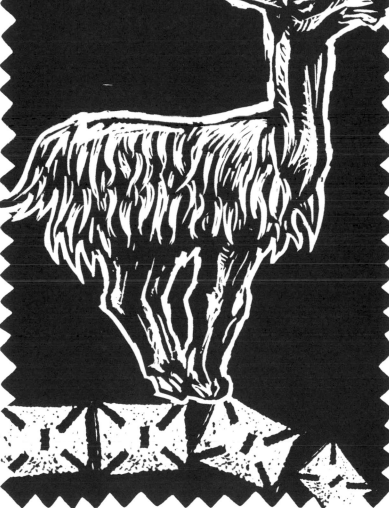

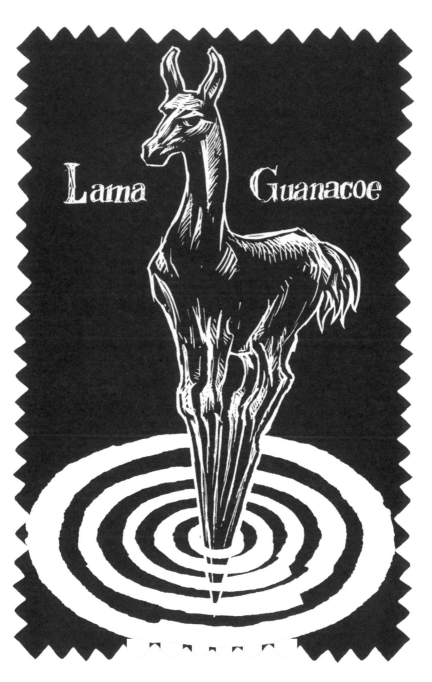

Lama Guanacoe

Lama Guanacoe

(*LAH-ma wuah-nah-KOH-eh*, Aymara)

In the Atacama Desert, the guanaco is a type of camel. With a gray face, small straight ears, and a body color that ranges from light brown to dark cinnamon and white on the underbelly, the creature is closely related to the llama. It has thick skin on its neck. Its wool is used in luxury items. In Quechua, the name is huanaco.

Lama guanacoe, according the *Amphibian Organisms* (1985), edited by Félix Silver-Bonattil, is said to be "the Platonic archetype on which all future guanacos are modeled." Among the Aymara of Bolivia, this animal chews on coca. It has a pedestrian quality—to the point that people use the neck skin to make shoes. But in certain parts of Torres del Paine, Chile, the *Lama guanacoe* has subtle powers. The moment it recognizes danger it sends signals to its peers. All guanacos immediately seek refuge as the *Lama guanacoe* sings a mysterious tune of longing and survival. The tune was once recorded by singer Atahualpa Yupanqui, who then turned it into a hit.

Mayahuel

(*mah-yah-* GWEL, Maya)

This female creature perched upon a maguey plant is a goddess of fertility and also a goddess of octli, the alcoholic beverage produced by fermented sap of the maguey plant, known in Mexico as pulque.

In the Codex Yoalli Ehecatl (discovered in 1805) and the Codex Cihuacoatl, also known as Codex Borbonicus, held in Paris's Bibliothèque de l'Assemblée Nationale, Mayahuel is represented with a baby in her hands.

A Maya fable called "A Little Bee" speaks to Mayahuel's power (from *In the Language of Kings: An Anthology of Mesoamerican Literature, Pre-Columbian to the Present*, edited by Miguel León-Portilla and Earl Shorris, 2001): Once upon a time, a little bee fell into a glass of pulque and began to sink. At that moment a little bird flew over, and upon seeing that the bee was sinking, the bird went in search of a leaf, which it took in its beak and brought to the bee. The little bee climbed up on top. And so its wings dried, it was able to fly, and off it went.

Another evening, the little bee was flying among the flowers, looking for honey to suck, when it saw a hunter with a slingshot who was about to shoot the very bird that had saved the little bee. The little bee flew at the hunter and stung him on the hand. The hunter fell ill. Not able to recover quickly, he drank pulque until he almost died. Mayahuel appeared to him.

The next morning, the little bee saw the hunter again. He was back and had fallen in love with a woman.

Said the little bee: one good turn begets another.

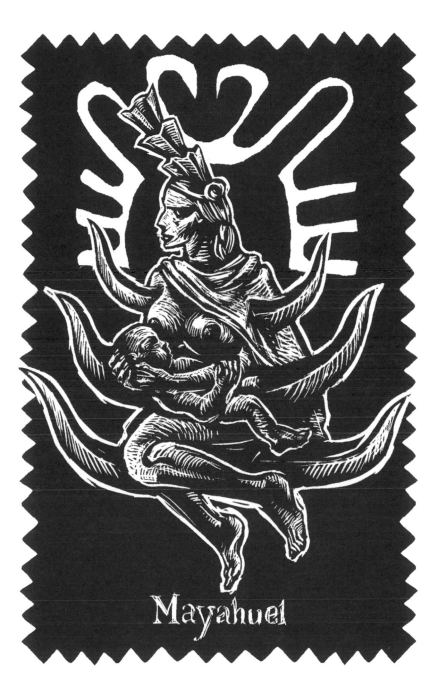

Mayahuel

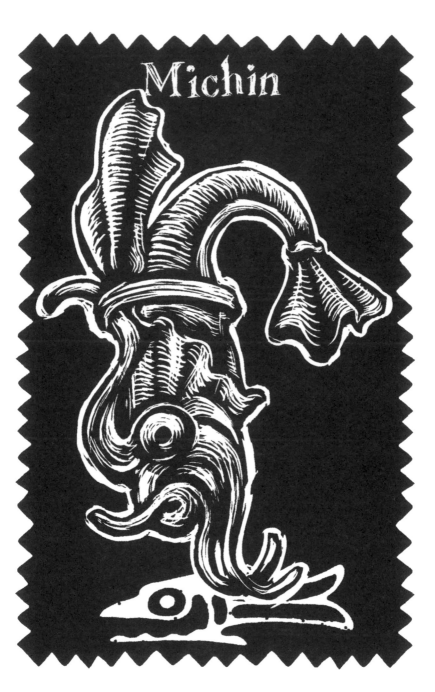

Michin

Michin

(MEE-*tcheen*, Nahua)

Michin literally means fish in Nahuatl. This fish with a trunk is said to be the spirit of Domingo Francisco de San Antón Muñón Chimalpahin Quauhtlehuanitzin, a.k.a. Chimalpahin (1579–1660). A descendant of the lords of Amecameca and Chalco, Chimalpahin wrote in Nahuatl a protomodern oral history of Mexico during the early part of the colonial period, from 1589 to 1615, based on interviews with indigenous people. Some of his work ended up in the hands of Mexican poet Carlos de Sigüenza y Góngora. He is depicted as a fish because he survived the Spanish conquest by hiding underwater.

Mictlantecuhtli

(*mee-klan-teh-KOOT-lee*, Nahua)

A skull with legs, this is a representation of the king of Mictlan (Chicunauhmictlan) as well as the lord of death. In an interview in the *Guardian* (April 17, 2014), J. K. Rowling, author of the Harry Potter saga, described how the inspiration for Lord Voldemort came from an Aztec encyclopedia she perused once at the British Library. "The legged skull made an impression on me. I can't for the life of me pronounce its name, hence the line 'he who shall not be named.'"

According to Luisita Barzilai's *The Aztecs: An Unknown Civilization* (2009), in *Historia verdadera de la conquista de la Nueva España* (*True History of the Conquest of New Spain*, finished in 1568), chronicler Bernal Díaz del Castillo claims that when Hernán Cortés's soldiers entered Tenochtitlán, which eventually became Mexico City, they saw two life-size clay statues of Mictlantecuhtli.

Mictlantecuhtli

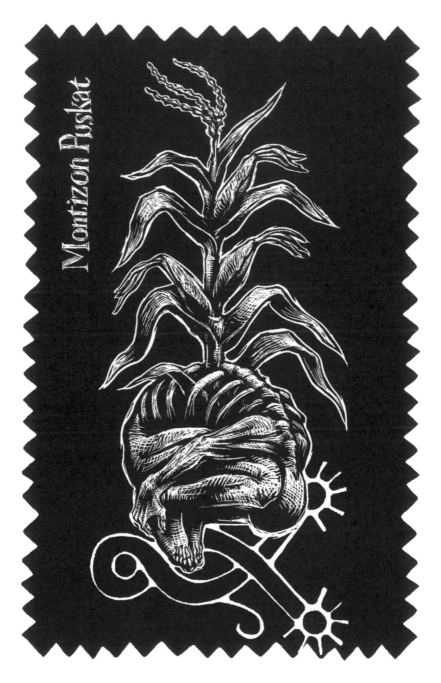

Montizon Puskat

Montizon Puskat

(*mon-TEE-son POO-skaht*, Aztec)

An animal in the form of a maize plant that grows in a human
spine. It is said to possess defectors, conspirators, spies,
traitors, and collaborators. Miguel León-Portilla features
the following quote in *The Aztec Image of Self and Society*
(1992): "For the Aztec, the self is a fortified structure. Its
sticks together by means of the moral fiber. The way to bring
down that structure is through betrayal. The punishment
is unavoidable: maize, the source of life, becomes a tool of
death" (22). Augusta Lilienthal, in *Improbable Creatures: The
World Columbus Should Have Found* (2017), makes a refer-
ence to lines from Alfred Lord Tennyson's poem "Marriage
Morning" in describing the Montizon Puskat "as envision-
ing maize not growing in the heart but in the spine (thorns
and briers)" (206):

> O heart, are you great enough for love?
> I have heard of thorns and briers.

Moyotl

(*moh-YOH-tl*, Nahua)

The moyotl is a poisonous mosquito designed to kill dictators and other bullies. Its sting causes a fatal septic attack in its victim. Its action is always surreptitious.

According to Nahuatl legends, mosquitos preceded the creation of humans. The gods allowed them to reign over the entire world. When humans came along, they seized power. And among humans, dictators and other bullies took control. The deities decided to limit such abuse by creating the moyotl.

It is no coincidence that in the biographical accounts of tyrants, at least those about whom an almost complete day-to-day record exists (Napoleon, Hitler, Stalin, Ceaușescu, Idi Amin, Fidel Castro, Hugo Chávez), there is always a scene, toward the end, in which they are "innocently" beaten up by a mosquito.

In a letter to me before his death in 2011, Brazilian fabulist Moacyr Scliar, the author of *O carnaval dos animais* (*The Carnival of the Animals*, 1968; 2nd ed., 2010), wrote, "The moyotl is multipurpose. It might look like Augusto Pinochet, Anastasio Somoza, Rafael Leónidas Trijillo, or Hugo Chávez. The fact that it acquired a different presentation depending on the moment it is seen speaks to its longevity."

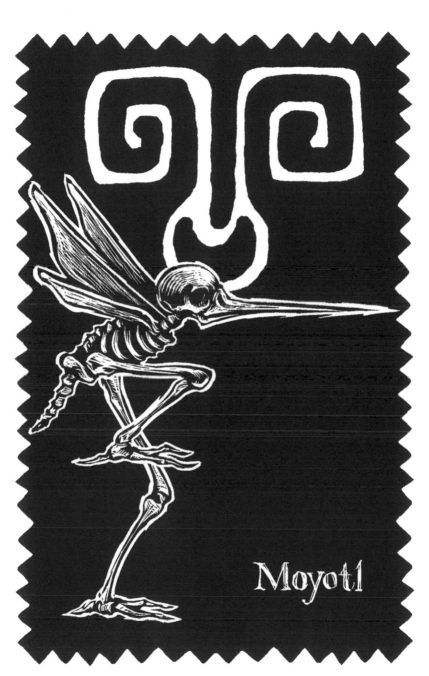

Moyotl

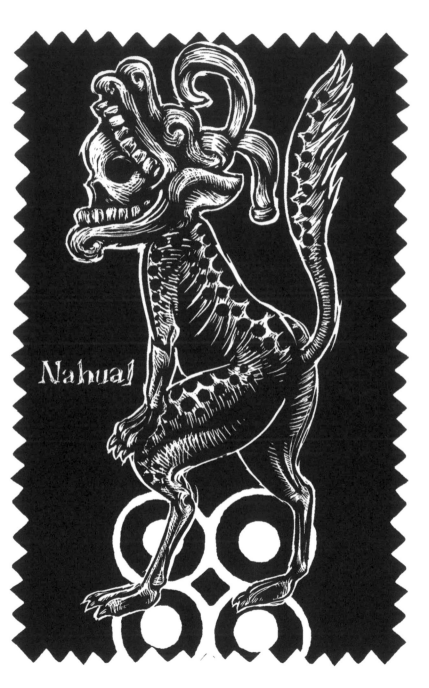

Nahual

(*na-wah-tl*, Aztec)

The word derives from *nahuālli*, meaning "magician," synonymous with *brujo*, "wizard." This most extraordinary human being is capable of adapting his physical appearance to the needs of the spirit. At one point, the creature might be a leopard, and at another point a pencil, a set of keys, a fox, a TV, a candle, or a set of glasses. In *Teachings of Don Juan: The Yaqui Way of Knowledge* (1968), Carlos Castaneda described his own adventures as a nahual (at times spelled nagual).

When I tried ayahuasca in a shamanic ceremony, I was transformed into a jaguar. The *curandera* (healer) in charge of the Amazonian ceremony told me that with the proper training, one day I might become a nahual.

The study of nahuales—fruitless as it might be, for the nahual is inherently a refutation of logic—is called nahualismo (or nagualismo). One of the earliest historians of this is Daniel Garrison Brinton, whose book *Nagualism: A Study of Native American Folklore and History* (1894) offers a survey of magical transformations in the American Southwest.

Oc

(онк, Maya)

This animal is a vicious dog. The symbol ridicules the ruling class. For instance, in the legend of San Juan Uzmeca the oc carries the blindfolded calavera of an aristocrat across a large expanse of land. The dog represents fate, destiny. The aristocrat runs around aimlessly looking for material possessions.

Samuel Taylor Coleridge read about ocs in a review of Ephraim Chambers's two-volume folio *Cyclopedia, or an Universal Dictionary of Arts and Sciences* (1728). The reviewer took Chambers to task for omitting important transatlantic information. As quoted in Benjamin Chester Marks's *Metaphysics of the Unreal* (2011), an alternative version of "Kubla Khan" (1799, two years after the poem's original inception) reads:

A damsel with a dulcimer
In a vision once I saw:
It was an Abyssinian maid
And on her dulcimer she played,
Singing of Mount Abora.
Could I return as an oc
Her symphony and song,
To such a deep delight 'twould win me,
That with music loud and long,
I would build that dome in air,
That sunny dome! those caves of ice!
And all who heard should see them there,
And all should cry, Beware! Beware!
His flashing eyes, his floating hair!
Weave a circle round him thrice,
And close your eyes with holy dread
For he on honey-dew hath fed,
And drunk the milk of Paradise.

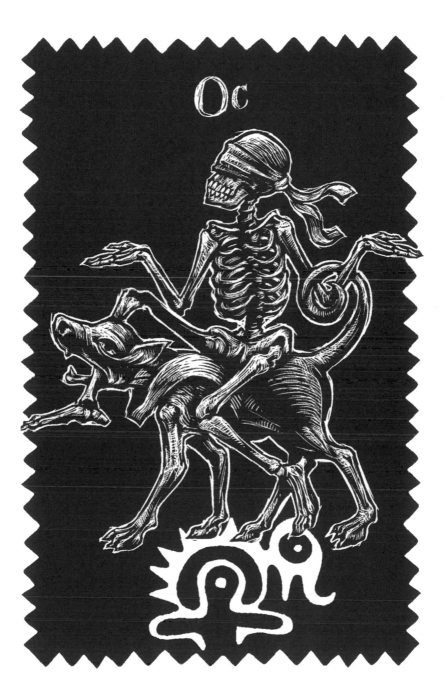

Oc

Ocelotl

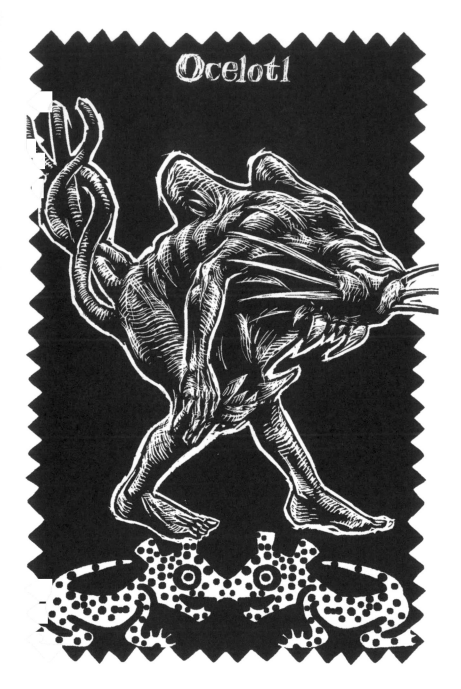

Ocelotl

(*oh-ZEH-lo-tl*, Nahua)

The word comes from classical Nahuatl *ocelotl*. The creature is represented by a headless jaguar with an enormous jaw but no face. On its cheeks it has prominent whiskers. It has human arms, legs, hands, and feet, as well as three tails, always intertwined.

Ocelotl is also a symbol for Martín Ocelotl (1496–ca. 1537), an Aztec priest forced by the Spanish Inquisition to convert to Catholicism. On the surface, he performed the Catholic rituals, but in fact he was still a shaman. His case ended up being decided by Bishop Juan de Zumárraga, who punished Ocelotl by sending him to prison in Seville, Spain. Ocelotl lost his head but not his heart.

In my novel *Last Exit, Paradise* (2005), inspired by Italo Calvino's *Sotto il sole giaguaro* (*Under the jaguar's sun*, 1986), a married couple experiencing difficulties in their relationship travel to Mexico, where, unbeknownst to them, a pre-Columbian magician turns the husband into an ocelotl and the wife into a princess. Both are sacrificed at the top of a pyramid, their bloody hearts offered to heaven.

Omecíhuatl

(*oh-meh-zee-wah-tl*, Nahua)

The Nahuas believed the story of creation to be about a pair of deities, Tonacacíhuatl and Tonacatecuhtli, meeting in heaven. Their fecund relationship resulted in the birth of four gods: Tlalauhqui, Tezcatlipoca, Camaxtle, and Huitzilopochtli.

Omecíhuatl is the feminine source from which these gods were shaped. Like the Shekhinah in Jewish *Kabbalah*, she is the glory of the divine presence, conventionally represented as light. In the account given by Niño Benítez to Fray Servando López de Grisantemo (*La flor de Omecíhuatl* [The flower of Omecíhuatl, 1529]), she is depicted as a list: "a fountain, two rivers, a tiger, an aqueduct, the future, seventeen numbers, Tonacacíhuatl pretending to be Tonacatecuhtli, a bonfire, the face of Tezcatlipoca, a cloud, an abandoned aviary, a prematurely born child, Tonacatecuhtli pretending to be Tonacacíhuatl, sixteen soldiers, and the shattered hand of a traitor."

Óscar Agustín Alejandro Shulz Solario (better known as Xul Solar), the Argentine visionary painter and friend of Borges, depicts in his watercolor on paper *Entierro* (1917) a funeral procession of celestial beings, which scholars suggests is either the universe in the beginning or else the afterlife. Their leader is an angelic figure floating above. In an article in Victoria Ocampo's magazine *Sur* (May 1929), Xul Solar states, "The angel is Omecíhuatl, goddess of life. She waits for me and the rest of us after death."

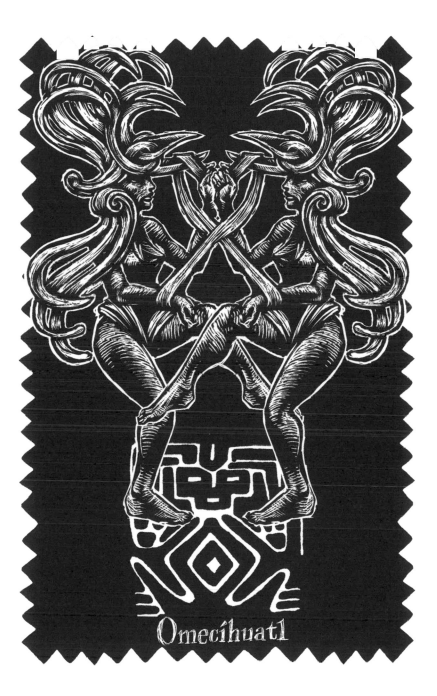

Omecíhuatl

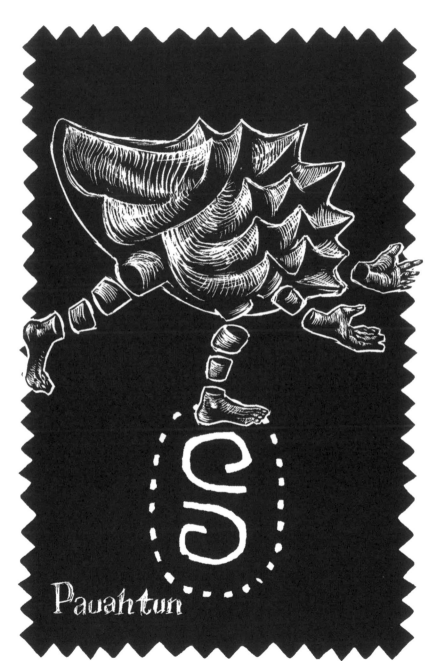

Pauahtun

Pauahtun

(*pah-gwah-TOON*, Maya)

This is a turtle shell or sea shell. The pauahtun is said to hold heaven with its strength. This creature is similar to an ocelotl in that it has become a symbol for Mariana del Carmen Carvajal (1577–1611), a niece of Luis de Carvajal the Younger, who was burned at the stake by the Spanish Inquisition in an auto-da-fé in the Plaza del Quemadero in Mexico City. Like her uncle, Mariana del Carmen was a secret Jew. In a letter dated September 11, 1604, she described herself as having the pauahtun, a shell so conspicuous it allowing her to hide in plain sight. Identified with the biblical matriarch Leah, she held steadfast to her Hebraic beliefs until the end, evading persecution. Three decades after her death, a book of recipes found among her belongings included a description of her survival strategies. "I am certain I will enter heaven," she wrote. "From above, I will sustain the spirit of those who hide in order to remain truthful to themselves." I have written about Carvajal the Younger's odyssey and, to a lesser extent, those of his relatives, in *The Return of Carvajal: A Mystery* (2019).

American filmmaker Orson Welles, while shooting *Touch of Evil* (1958) with Charlton Heston and Janet Leigh (as well as appearances by Marlene Dietrich and Zsa Zsa Gabor), read "a small, strange book" called *Pauahtun's Revenge* (1st ed., 1952), by Stewart McDuffy. He was fascinated by "the Mayan being that mutates incessantly and thrives when being exposed to radio airwaves." When Universal Pictures decided to reedit *Touch of Evil*, Welles said, "Pauahtun is allowing the heavens to loosen up."

Tepeyólotl

(*teh-peh-*YOH*-loh-tl*, Aztec)

This is the god of echoes and earthquakes. The word is derived from the Nahuatl words *tepētl* (mountain) and *yōllōtl* (heart or interior). Tepeyólotl is usually depicted as a cross-eyed devil with a swelling and rolling body at the end of which emerges a crown of feathers. Tepeyólotl is believed to have been the inspiration for the pale-skinned humanoid monster with his eyeballs in the palms of his hands in Mexican filmmaker Guillermo del Toro's *El laberinto del fauno* (*Pan's Labyrinth*, 2006).

An echo is a reflection of sound. And an earthquake is the shaking of the surface of the earth that results in an explosion of echoes.

Since time immemorial, Mexico City has suffered from earthquakes. This is because Tepeyólotl, a sibling of Quetzalcóatl, was angry for having been exiled from the divine pantheon. To quiet him, Quetzalcóatl forced him to drink a potion that made him sleep. But the potion was imperfect, and now Tepeyólotl suffers from tremors. Every time he threatens to wake up, the ground in Mexico City shakes, which results in buildings crumbling, fires, death, and loud echoes.

In the earthquake of 1985, witnesses claimed to have seen a cross-eyed devil with a rolling body spit feathers near destruction sites.

In his collection of Yiddish poetry *Shtot fun palatsn* (*City of Palaces*, 1936), with illustrations by Diego Rivera, Yitzhak (a.k.a. Isaac) Berliner, a Polish immigrant to Mexico, writes to Tepeyólotl (my translation):

> You shake the heart,
> Tepeyólotl,
> deity of tremors and fears,
> returning us
> to the origin
> where death
> reigns supreme.

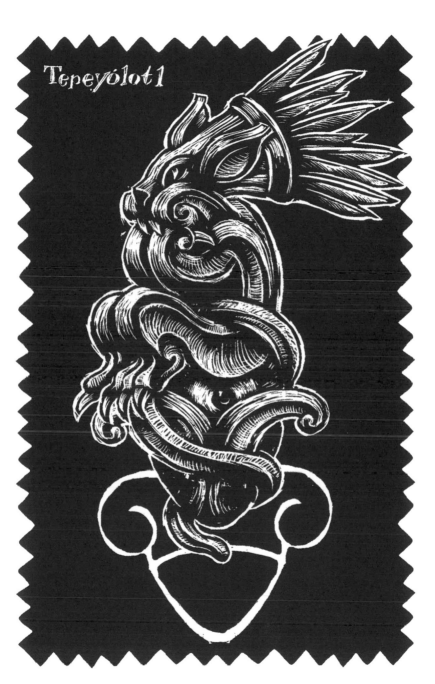

Tepeyólotl

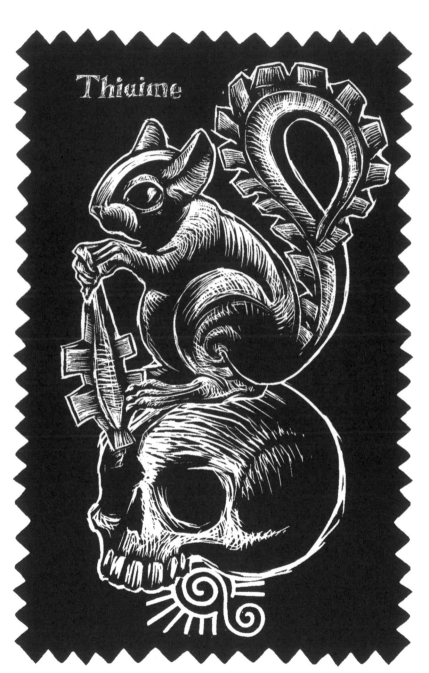

Thiuime

(*TEE-YOO-EE-meh*, Tabascos)

Thiuime, represented by a black squirrel, is, for the Tabasco people, the goddess of war. She roams the battlefield, lamenting the disappearance of camaraderie.

I once met a US army veteran from the Iraq War who claimed to have seen Thiuime in Fallujah. Originally from the Mexican city of Villahermosa, Sgt. Leopoldo F. Márquez was wounded during a military operation. He recounted to me the pain he felt in his left foot, which had been severely wounded after a landmine exploded. He said he was visited by the black squirrel. "She stared at me for several minutes. I begged her, saying: I'm not ready to die. The squirrel leaped from where she stood and disappeared."

Tlalcíhuatl Toad

(*tlal-TZI-guah-tl* TOAD, Nahua)

This is an enormous sea monster in the shape of a toad, at once fertile and chaotic, with its head turned upside down. The deities Quetzalcóatl and Tezcatlipoca are said to have cut it in half. Even though it was a venerated god, the Nahuas make passing reference to the Tlalcíhuatl Toad in their literature.

Mexican author José María Zugazagoitia, in his book *Bizco* (Squinting, 1967), about a Holocaust survivor and his victimizers meeting again in the neighborhood of a big Latin American metropolis, has the unnamed narrator describe the survivor's nightmares thus:

> He dreams of the Tlalcíhuatl Toad that looks like an SS commander. He then dreams that the same dreams reappear to him nightly. Mentally, he sees himself dreaming that he dreams and also sees himself writing that he dreams and dreaming that he writes. He remembers himself writing and also dreaming that he writes what he dreams. And he remembers that he sees himself writing that he dreams and dreaming that he remembers himself writing. Afterward, he imagines the Tlalcíhuatl Toad looking like an SS commander while dreaming of him writing that he remembers imagining that he dreams nightly of the Tlalcíhuatl Toad mentally seeing himself dreaming in the imagination of a memory.

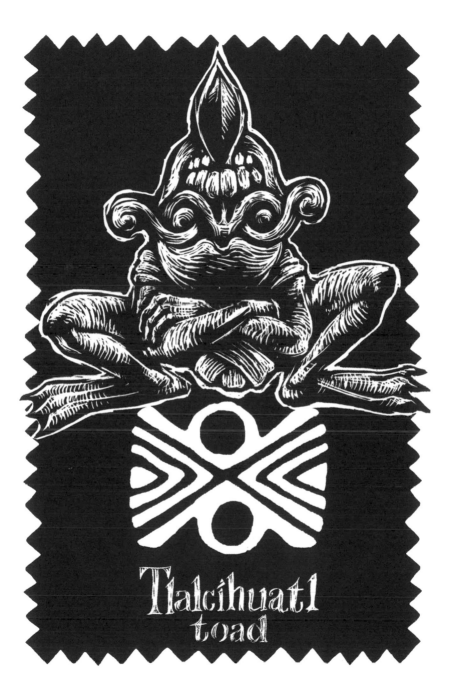

Tlalcihuatl
toad

Tochtli

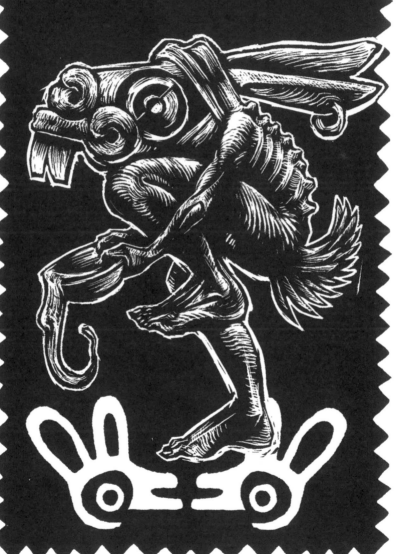

Tochtli

(*TOHCH-tlee*, Nahua)

In Nahuatl, the word means rabbit, an animal that symbol-
izes pulque, a drink made of fermented sap of the maguey
plant. The Tochtli appears to a drunkard, cautioning him
about what's to come.

A poem attributed to the prince-poet Netzahualcóyotl
portrays the Tochtli thus:

> He alone,
> the Giver of Life.
> Empty wisdom had I.
> The Tochtli came,
> I asked: perhaps no one?
> Perhaps it is me?
> I was not content with people.
> I let myself loose.
>
> Precious things have disappeared.
> The Tochtli ran away.
> Giver of Life,
> have I lost the sense of self?

(In somewhat different form, this poem appears in *In the
Language of Kings: An Anthology of Mesoamerican Literature,
Pre-Columbian to the Present*, edited by Miguel León-Portilla
and Earl Shorris, 2001.)

Toci

(*тон-see*, Nahua)

Toci is a metaphysical creature of translucent substance. It moves unrecognized in the air. Baruch Spinoza, in *Ethics* (1664–65), makes tangential reference to it, describing the Toci as a substance that "is in itself and is conceived through itself, i.e., that whose concept does not require the concept of another thing, from which it must be formed." Spinoza adds four points, the fourth being rather cumbersome: (1) that as a substance, Toci cannot be produced by another substance, (2) that it is necessarily infinite, (3) that it must be conceived through itself, and, crucially, (4) that "Toci, or a substance consisting of infinite attributes, each of which expresses eternal and infinite essence, necessarily exists, which means that if anyone denies this, then that person must conceive, if the person is able, that Toci does not exist. Therefore, by the axiom 'If a thing can be conceived as not existing, its essence does not involve existence,' Toci's essence does not involve existence. But this is absurd. Therefore, Toci necessarily exists, q.e.d."

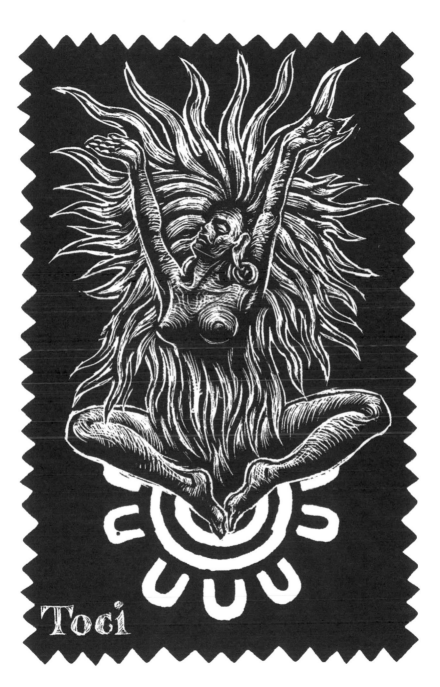

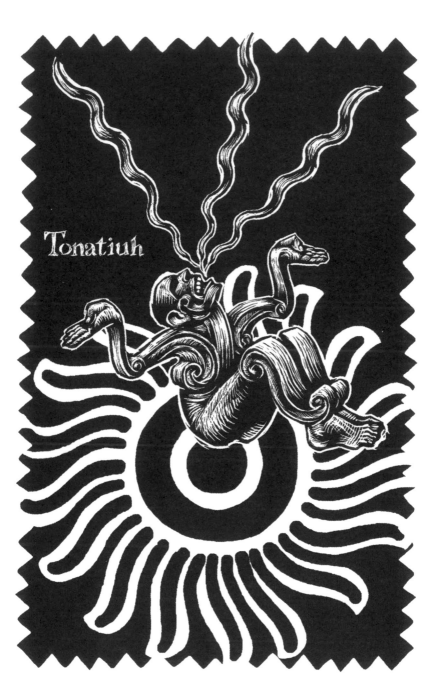

Tonatiuh

(*toh-nah-*TYOO, Nahua)

Tonatiuh is the fifth god of the sun. (The first four are Tiger, Wind, Water, and Rain.) He is also the patron saint of warriors. And in some accounts, he is the sun's son. His face is believed to be at the center of the Aztec Calendar Stone. His defining color is red. He wears feathers. Eagles surround him.

Bernal Díaz del Castillo, in *Historia verdadera de la conquista de la Nueva España* (*The True History of the Conquest of New Spain*, finished in 1568), suggests that the Aztecs mistakenly believed red-haired conquistador Pedro del Alvarado, widely known for his aggressive character, was an incarnation of Tonatiuh himself. In a particular scene, Díaz del Castillo tells of an encounter between the Aztec emperor Moctezuma and Hernán Cortés and Alvarado. The following sequence precedes that scene:

> The ambassadors with whom they were travelling gave an account of their doings to Montezuma [Moctezuma], and he asks them what sort of faces and general appearance these two Teules had [Cortés and Alvarado] who were coming to Mexico, and whether they were Captains, and it seems that they replied that Pedro de Alvarado was of very perfect standing both in face and person, that he looked like the Sun, and that he was a Captain, and in addition to this they brought with them a picture of him with his face very naturally portrayed and from that time forth they gave him the name of "Tonatio" [Tonatiuh], which means the Sun, or the Child of the Sun, and so they called him ever after.

Uturunku

(*OO-TOO-roon-KOO*, Inca)

The uturunku is a cougar commonly known as a cata-
mount, mountain lion, panther, or puma. It has a round
head and erect ears. Slender and agile, with a powerful
neck and jaws full of sharp teeth it captures its prey and
uses its claws to manipulate it.

According to Paul Meredith's *Surplus: Animals from
Diogenes to Becket* (1997), in Inca mythology, the fearlessness
of the uturunku leads humans into emotional journeys.
W. H. Hudson, in *The Naturalist in La Plata* (1892), offer-
ing anecdotal evidence, states that uturunkus—he simply
calls them pumas—are considered by the Patagonian locals
to be mythical beings. In some legends, the animal laughs
in a way that heals the soul.

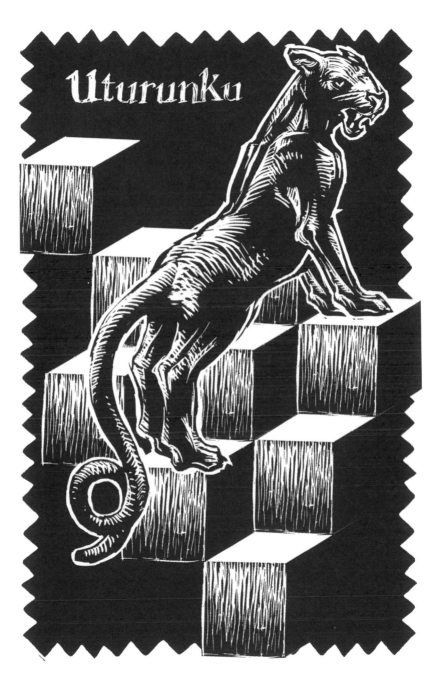

Uturunku

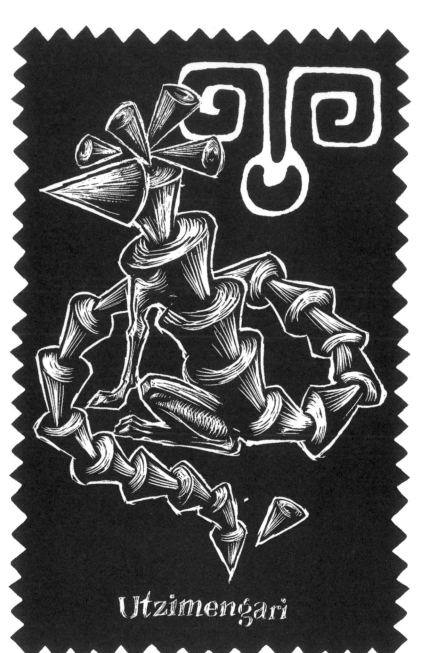

Utzimengari

Utzimengari

(oo-tzee-men-GAH-ree, Maya)

The Utzimengari is an anima (according to Carl Gustav Jung, a man's unconscious feminine side) made exclusively of metaphorical cones. It has two extremities, one in the form of a lizard, the other in the form of a deer. The Maya believed the Utzimengari was surplus matter with no real value in the world. Briceida Cuevas Cobb sings to it thus in her poem "Carousel of Emptiness":

> Carousel of emptiness.
>
> Why are you with us?
>
> The gods lost track.
> They overestimated.
> Nothing for nothing
> is nothing . . .
>
> Utzimengari, what's in your name?
> We, too, are in vain.
> The gods made us
> and then they forgot us.
>
> Why are we like you?
>
> Carousel of emptiness.

Xiuhtilán

(*tchee-oo-tee-TLAHN*, Nahua)

The anachronism of the Xiuhtilán is unavoidable: a seated pre-Columbian man wearing glasses. Over his head is a sombrero with cuneiform signs written on its edges and containing a large fire.

In one now-lost manuscript of the Babylonian Talmud, the Xiuhtilán is anachronistically invoked in a halakhic dispute:

> Rabbi Eliezer suggests that the world was created by the Almighty in an instant. Rabbi Yehoshua believes the instant is a reference to three successive Sabbaths—that is, the amount contained in a lunar month. Rabbi Israel ben Hanina makes the case that you don't see the world as it is; instead, you see it as you are. He adds that a merchant traveled across the sea and came back with a drawing of Xiuhtilán, a man with a portentous memory. Memory is the essential element through which the world is created. Without memory, there is no day one, day two, day three. Without memory, there is no language. The Almighty is the source of all memory as well as the source of all language. The only limitation the Almighty has, Blessed be He, is that he cannot change the past. Rabbi Eliezer asks: But can the Almighty change memory? Rabbi Israel ben Hanina responds: The Almighty can change memory but cannot change the past."

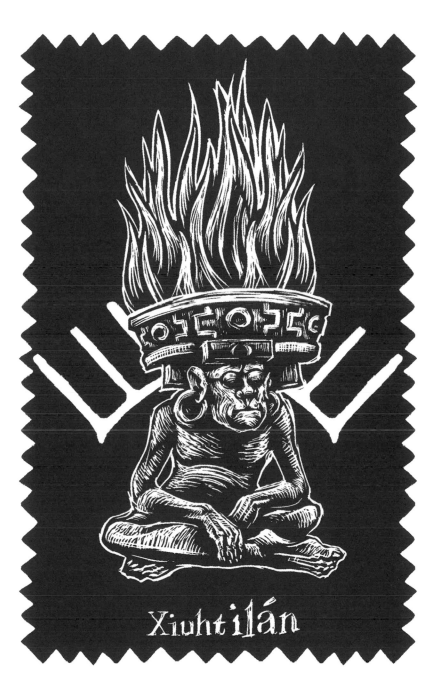

Xiuhtilán

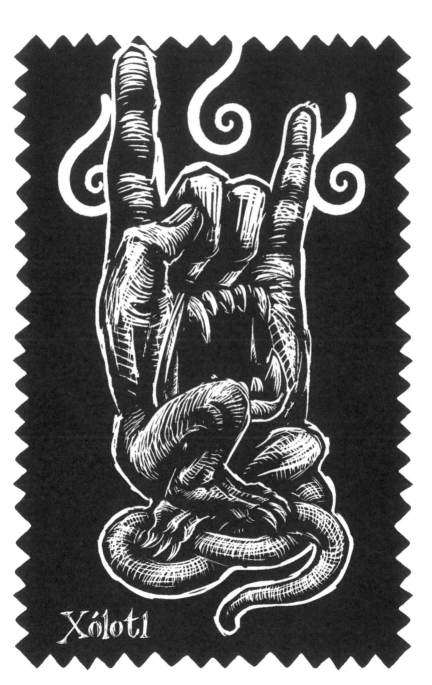

Xólotl

Xólotl

(TCHO-lo-tl, Nahua)

The Xólotl is the Nahua god of light and darkness. He protected the sun from disappearing on the firmament. It is also associated with dogs, which, according to Hubert Howe Bancroft's *The Native Races* (1883–86), are "in charge of leading the soul of the dead through the underworld." But Xólotl is also about mutability. He has a stunning capacity to transform himself: he might be a dog with earrings at one point, an enormous mouth at another, a devouring tongue at yet another. The amphibian creature axólotl descends from him. The Argentine writer Julio Cortázar, whose novel *Rayuela* (*Hopscotch*, 1963) is about the inevitability of exile, paid tribute to it in an eponymous story. He portrays these salamanders as having Aztec faces. "I imagined them aware, slaves of their bodies, condemned infinitely to the silence of the abyss, to a hopeless meditation" (579).

Years ago, I had an axólotl. A shaman asked me to take care of it. Since it needed water, I placed it in a bathtub.

Xtabay

(*TZAH-bey*, Maya Lacandon)

The Xtabay is a female demon residing in the Yucatán Peninsula. Always wearing a black dress, she seduces men who are out at night. She awaits them under a ceiba tree. After they "possess" her, she turns into a poisonous serpent and devours them.

The Xtabay is the product of a rivalry between two women, the sinner Xkeban and the virtuous Utz-colel. When each of them died, the town went to their funeral. The body of Xkeban, who was promiscuous, smelled like perfume; in contrast, Utz-colel's remains exuded a bad odor. The moral of the legend is that virtue doesn't manifest itself in actions but is within the heart. The combination of the two became Xtabay, although her mother was Xtab, the goddess of suicide, who allures those suffering from depression, inviting them to jump into the next life.

Like the centipede, Xtabay has numerous legs. And instead of hair, it grows trees from which numerous branches emerge. The Xtabay is therefore seasonal: in spring, it is fully covered with leaves; in winter, it is barren. In Jesús Azcorra Alejos's *Diez leyendas mayas* (Ten Mayan legends, 1998), the Xtabay is described as a variation of the myth of La Llorona, the Weeping Woman.

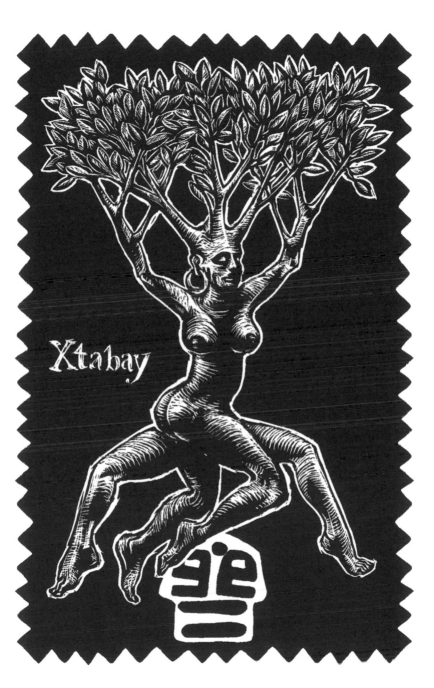

Xtabay

Zulin

Zulin

(*TCHOO-leen*, Aztec)

The Zulin is a double bird—or else, a set of birds—that exists by looking at the mirror. Its shape depends on position: one zulin has a pair of wings, one on the left side and the other on the right. The other zulin also has a pair of wings, one on the right side and the other on the left. Neither zulin knows which is which. Everything connected with the Zulin is multiplied by two, then reversed, and finally relocated upside down and inside out.

Japanese-American novelist Aki Takahashi, in his book *Is the End of Time in Time?* (1985), whenever Zulin is mentioned, repeats the word twice. The narrator makes a reference to Zulin Zulin as "an enemy of the INGlings (Inter-Noctural Gammas [beings]), sewer-dwelling people who have developed their own culture. They worship a tilapia fish with violent tendencies" (78). Zulin Zulin eats tilapia as a strategy to counterbalance their power.

Further Readings

Barziali, Luisita. *The Aztecs: An Unknown Civilization*. Miami: Arcadia, 2009.

Borges, Jorge Luis, with Margarita Guerrero. *The Book of Imaginary Beings*. Translated by Andrew Hurley. Illustrated by Peter Sís. New York: Viking, 2005.

Carrasco, David. *Quetzalcoatl and the Irony of Empire: Myths and Prophecies in the Aztec Tradition*. Chicago: University of Chicago Press, 1982.

Chinchilla Mazariego, Oswaldo. *Art and Myth of the Ancient Maya*. New Haven: Yale University Press, 2017.

Espaillat, Rigoberto F. *Jabberwock in Latin America: The Uses of Nonsense*. New York: Pranker & Windup, 2002.

Fariña, Richard A., Sergio F. Vizcaíno, and Gerry De Iuliis. *Megafauna: Giant Beasts of Pleistocene South America*. Bloomington: Indiana University Press, 2013.

Gaiman, Neil. *Norse Mythology*. New York: W. W. Norton, 2017.

Henderson, Caspar, ed. *The Book of Barely Imagined Beings: A 21st Century Bestiary*. Chicago: University of Chicago Press, 2012.

León-Portilla, Miguel, ed. *Pre-Columbian Literatures of Mexico*. Norman: University of Oklahoma Press, 1969.

León-Portilla, Miguel, and Earl Shorris, eds. *In the Language of Kings: An Anthology of Mesoamerican Literature, Pre-Columbian to the Present*. New York: W. W. Norton, 2001.

Lilienthal, Augusta, ed. *Improbable Creatures: The World Columbus Should Have Found*. New York: Pranker & Windup, 2017.

Marks, Benjamin Chester. *Metaphysics of the Unreal: On the Taxonomy of Particularism*. Denver: ScholarPort, 2011.

Meredith, Paul. *Surplus: Animals from Diogenes to Becket*. London: Regency, 1997.

Morrison, Elizabeth, ed. *Book of Beasts: The Bestiary in the Medieval World*. Los Angeles: The J. Paul Getty Museum, 2019.

Nigg, Joseph, ed. *The Book of Fabulous Beasts: A Treasury of Writing from Ancient Times to the Present*. New York: Oxford University Press, 1999.

Romo, Claudio. *The Book of Imprudent Flora*. Translated by David
 Haughton. Berkeley, CA: Gingko Press, 2017.

Schwartz, Howard. *Tree of Souls: The Mythology of Judaism*. New York:
 Oxford University Press, 2007.

Stavans, Ilan. *Popol Vuh: An Illustrated Retelling*. Brooklyn: Restless
 Books, 2020.

Strassberg, Richard E, ed., trans., with comm. *A Chinese Bestiary:*
 Strange Creatures from the Guideways Through Mountains and Seas.
 Los Angeles: University of California Press, 2018.

Syropoulos, Spyros. *A Bestiary of Monsters in Greek Mythology*. Oxford:
 Archaeopress, 2018.

Index

maize, 57
Major Trends in Jewish Mysticism
(Scholem), 10
Manual de zoología fantástica (Borges
and Guerrero), x, 18
Marks, Benjamin Chester, 62
Márquez, Sgt. Leopoldo F., 73
"Marriage Morning" (Tennyson), 57
Martínez, Vier Librado, 10
Maya, 9, 10, 17, 26, 29, 30, 38, 42, 50,
69, 85
Maya Grammar, A (Torzer), 30
Mayahuel, 50
Mayan being, 69
Mayan Lacandon, 90
Masse und Macht (Canetti), 5
McDuffy, Stewart, 69
*Medical Treatise, Exhibiting an
Emended Synopsis of Reptiles, with
Experiments Concerning Venoms
and Antidotes for Austrian Reptiles*
(Laurenti), 37
Melquíades, x
Meredith, Paul, 82
Mesoamérica, 14
mestizo, 22
Metamorphosis, The (Kafka), 6
Metaphysics of the Unreal (Chester), 62
Mexican penicillin, 37
Mexicans, 6
Mexico, ix, xii, 22, 25, 50, 53, 65
Mexico City, 29, 54, 69, 70
Meyrink, Gustav, 10
mezcal, 37
Michin, 53
Mictlan, 54
Mictlantecuhtli, 54
Middle High English, 6
Montizon Puskat, 57
Montezuma (Moctezuma), 81
mosquito, 58
Mount Abora, 62
mountain lion, 82
Moyotl, 58
Muñón Chimalpahin
Quauhtlehuanitzin, Domingo
Francisco de San Antón, 53

Museo de Antropología, 29

Nahua, 2, 6, 10, 13, 14, 21, 25, 34, 41,
53, 54, 58, 65, 74, 77, 78, 81, 86, 89
Nahuas, 66, 74
Nahual (nagual), 61
nahuallismo, 61
Nahuālli, 61
Nahuatl, 6, 13, 14, 21, 41, 53, 54, 58, 70
Nahuatl legends, 548
nagual. *See* nahual
*Nagualism: A Study of Native American
Folklore and History* (Brinton), 61
nagualismo, 61
Napoleon, 58
Native Races, The (Bancroft), 89
Naturalist in La Plata, The (Hudson), 82
Netzahuacóyotl, 77
Nevada, 6
New World, x

Ocampo, Victoria, 66
Oaxaca, 14
Obscene Bird of Night, The (Donoso), 10
Obsceno pájaro de la noche, El
(Donoso), 10
Oc, 62
Ocelotl, 65
Ocelotl, Martín, 65
Octli, 50
Odyssey, The (Homer), viii
Omecihuatl, 66
One Hundred Years of Solitude (García
Márquez), x
Ortalis cunicollis, 13
Ortalis columbiana, 13
Ortalis cinereiceps, 13
Ortalis leucogrstra, 13
Ortalis poliocephala, 13
Ortalis vetula, 13
Oven, The (Stavans), viii

Palante, Sandra Raziel, 42
pale-skinned humanoid monster, 70
Pan's Labyrinth (Toro), 70
panther, 82
papalote, 41